CATS & LIONS

# CATS & LIONS

MITSUAKI IWAGO

CHRONICLE BOOKS

SAN FRANCISCO

First published in the United States in 2015 by Chronicle Books LLC.

Photographs © 2013 by Mitsuaki Iwago.
English translation © 2015 by Chronicle Books LLC.
Photographs originally published by Crevis Inc., Tokyo, Japan, in 2013 as *Cats & Lions*.

Library of Congress Cataloging-in-Publication data available.
ISBN 978-1-4521-4049-0

Manufactured in Korea.

Design by Nami Kurita.

10 9 8 7 6 5 4 3 2 1

Chronicle Books LLC
680 Second Street
San Francisco, CA 94107
www.chroniclebooks.com

# INTRODUCTION

Human beings tend to compare things in order to understand how they fit in the world. But comparing cats and lions does not have to be so simple. By taking a closer look, we can open our eyes wider and see the world from a broader perspective. As we avoid making quick judgments, we see instead the complexity and detail of the world we share with these majestic felines, big and small.

When cats go out in the morning, they seem to sense the day's weather through their whiskers. Their ears are alert to what's around them and their noses pick up on a delicious meal. Cats maintain a direct connection with their wild instincts. I believe we humans also have deeper instincts that we can tap into when we use all our senses.

The lion is a wild animal and does not have an easy life. We often view them as "the king of the beasts," though they are just one part of the savanna's ecosystem. When tourists visit Africa, lions act tired and pretend to fall asleep. They save their energy for the hunt, just after the tourists leave. Lions remind us that things are not always as they seem.

By looking closer at cats and lions, we as humans can better connect with our own instincts and challenge our assumptions about the world.

Mitsuaki Iwago

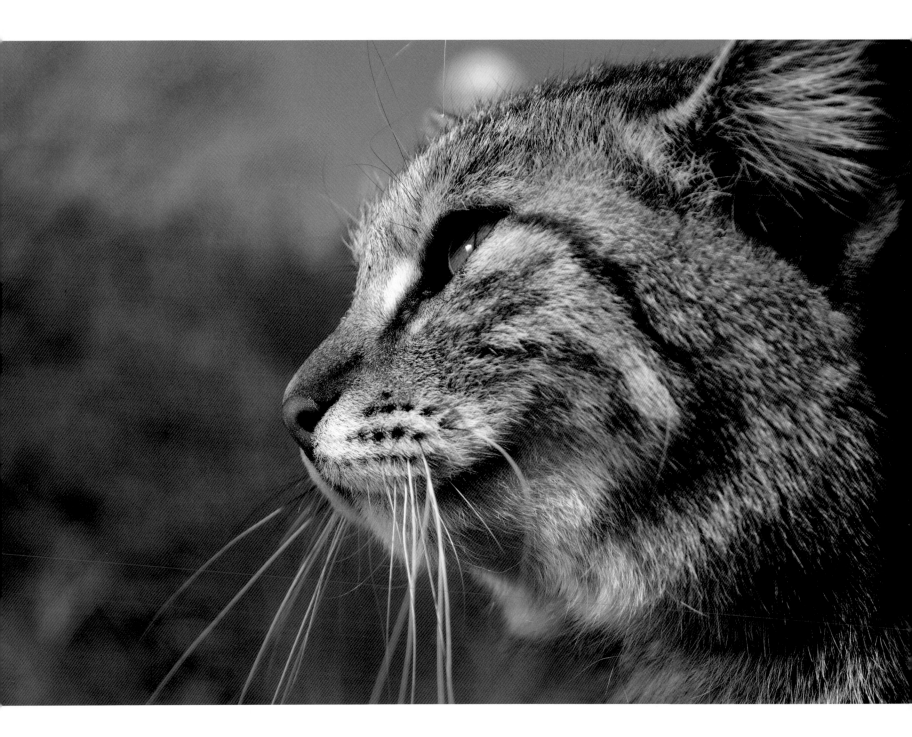

Keeping a close watch.

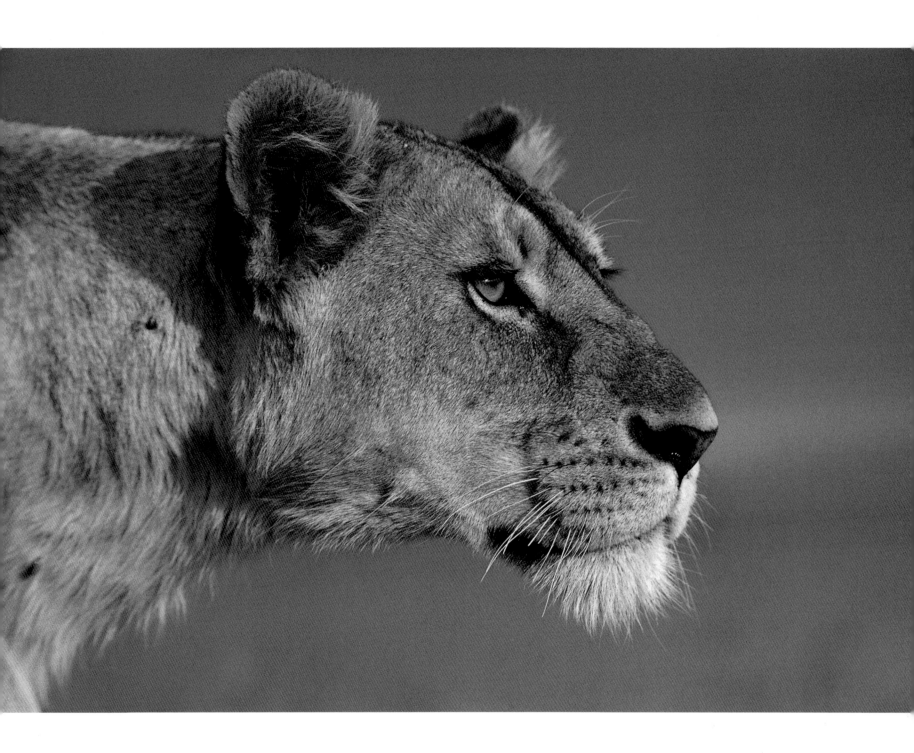

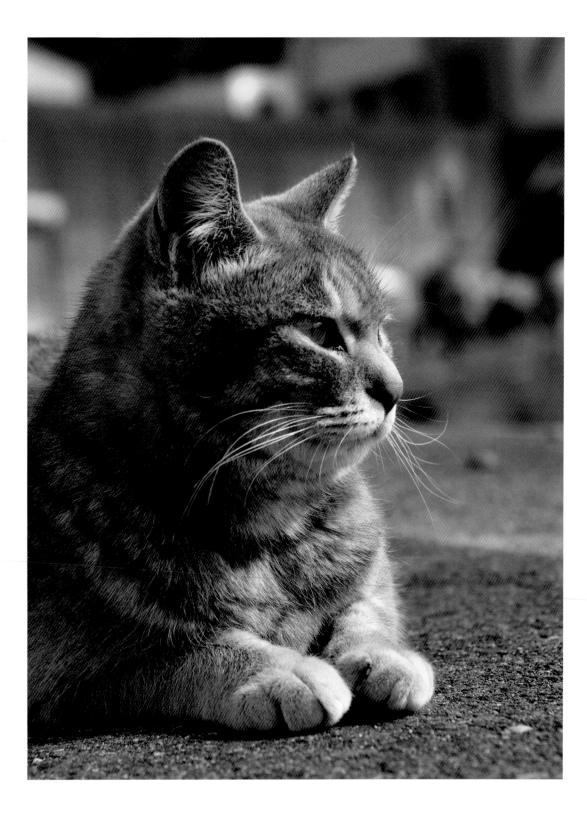

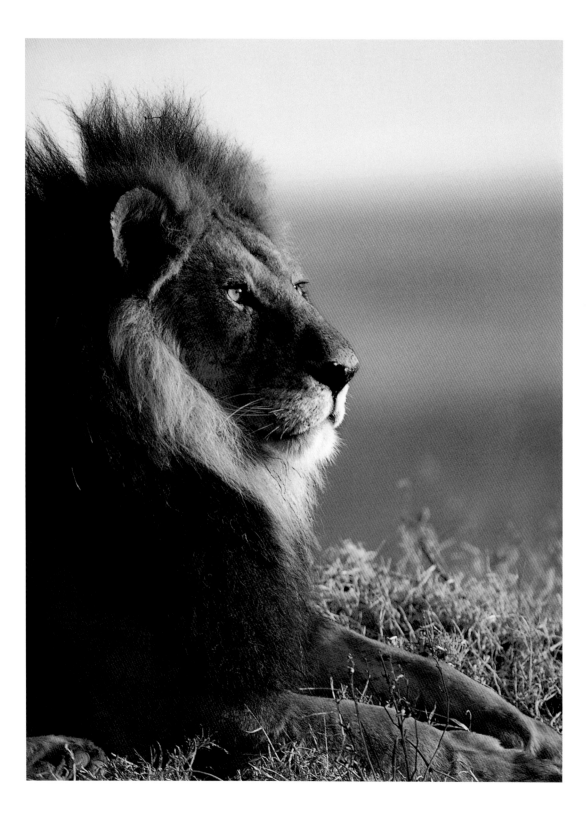

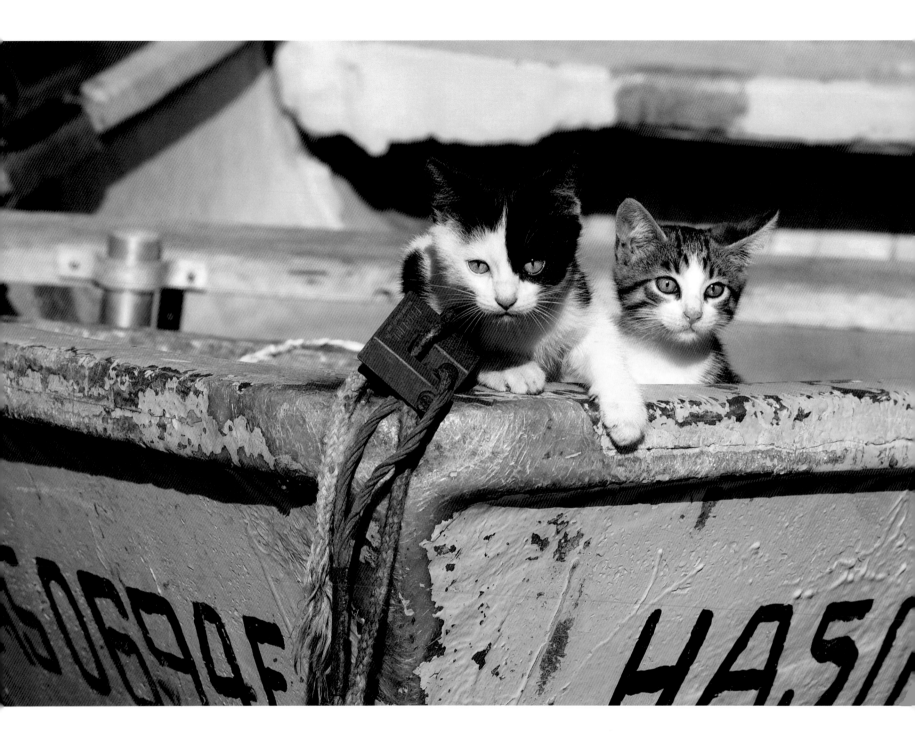

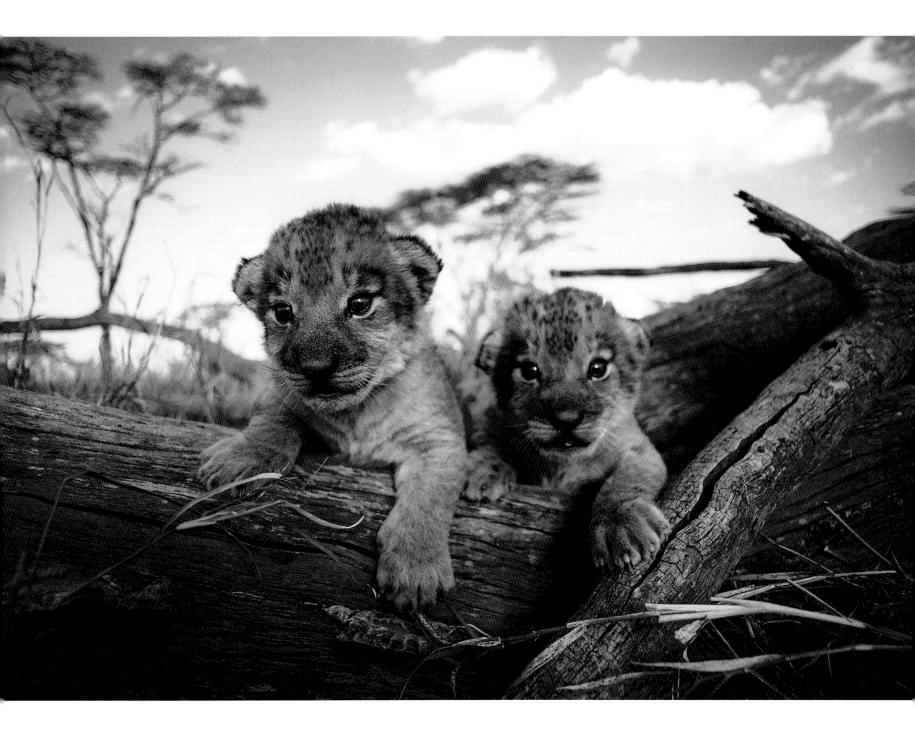

Brothers waiting for their mother.　　11

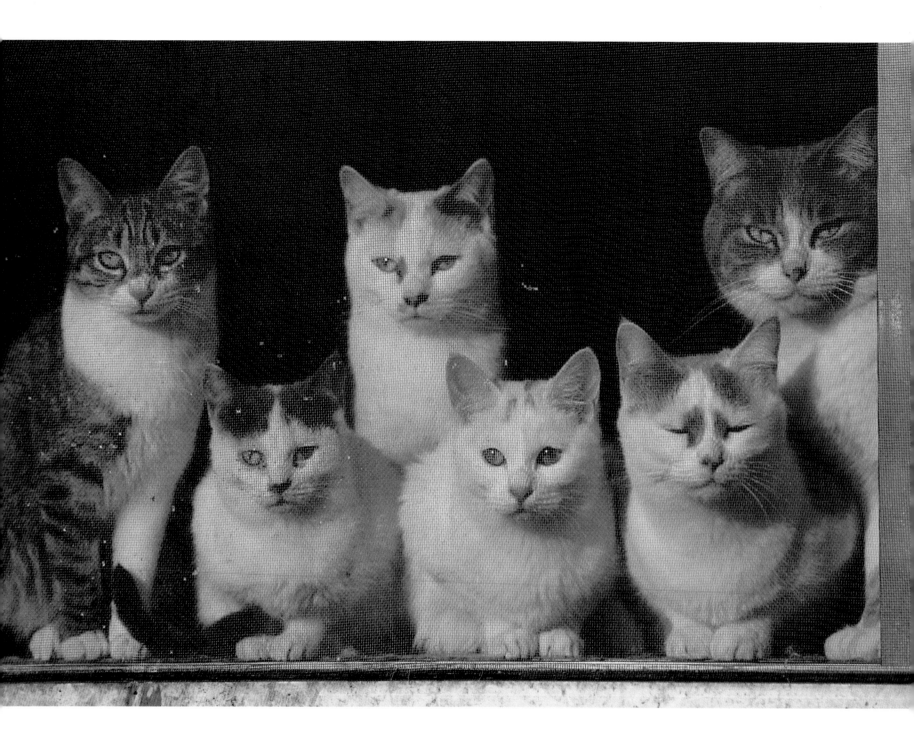

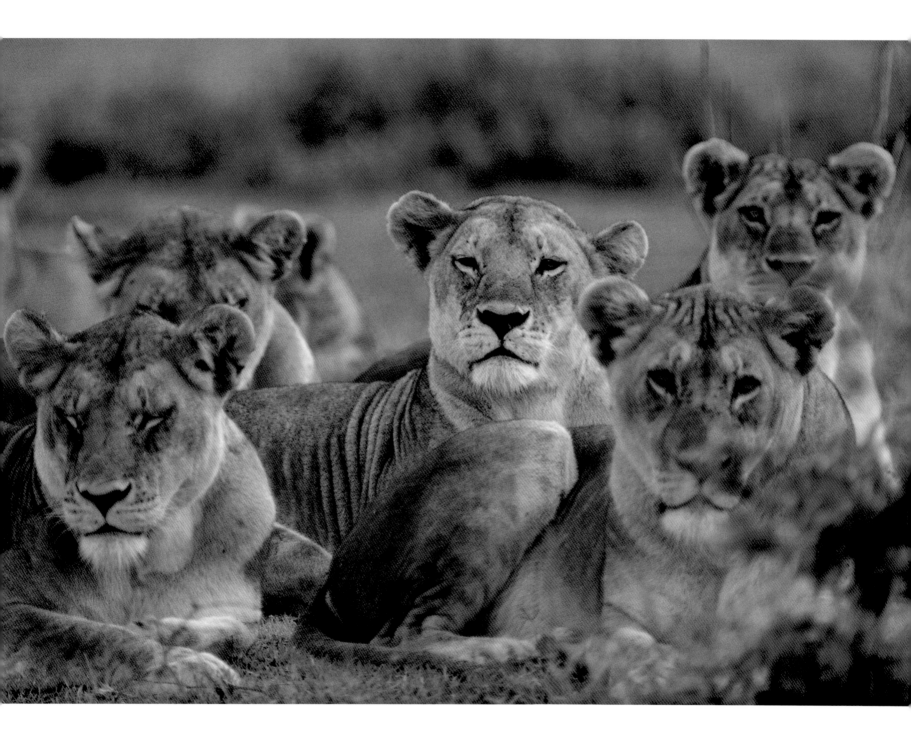

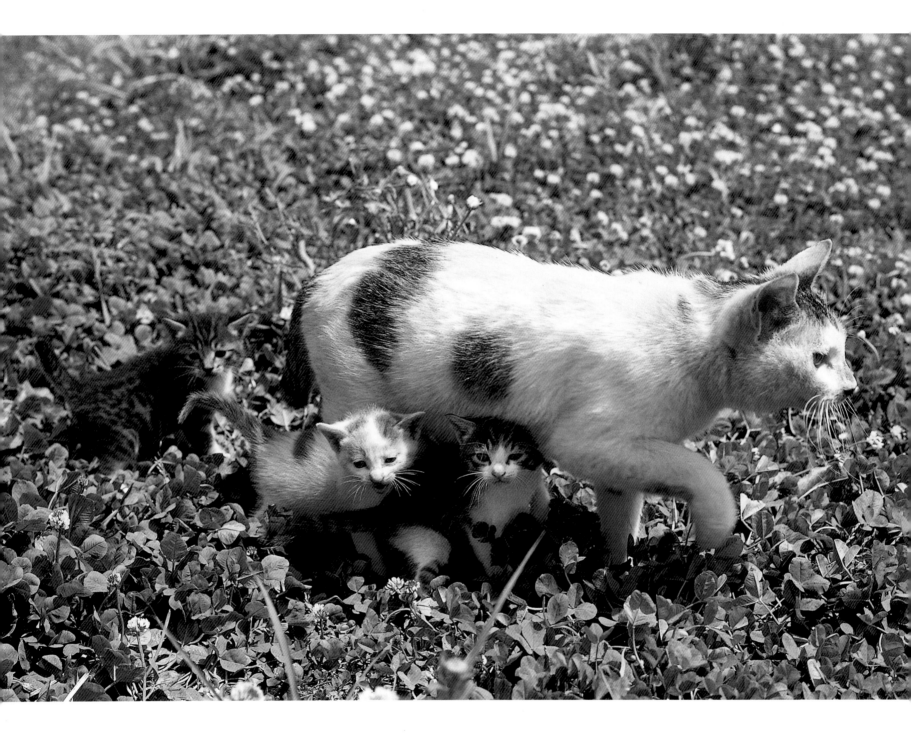

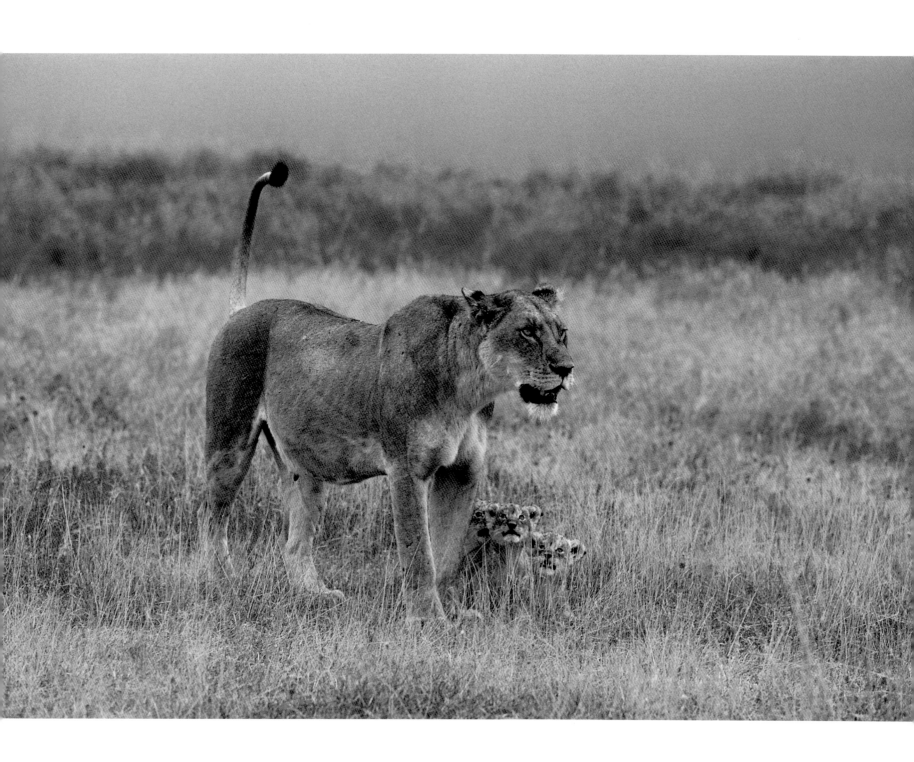

The young are aware of their mother's every movement.

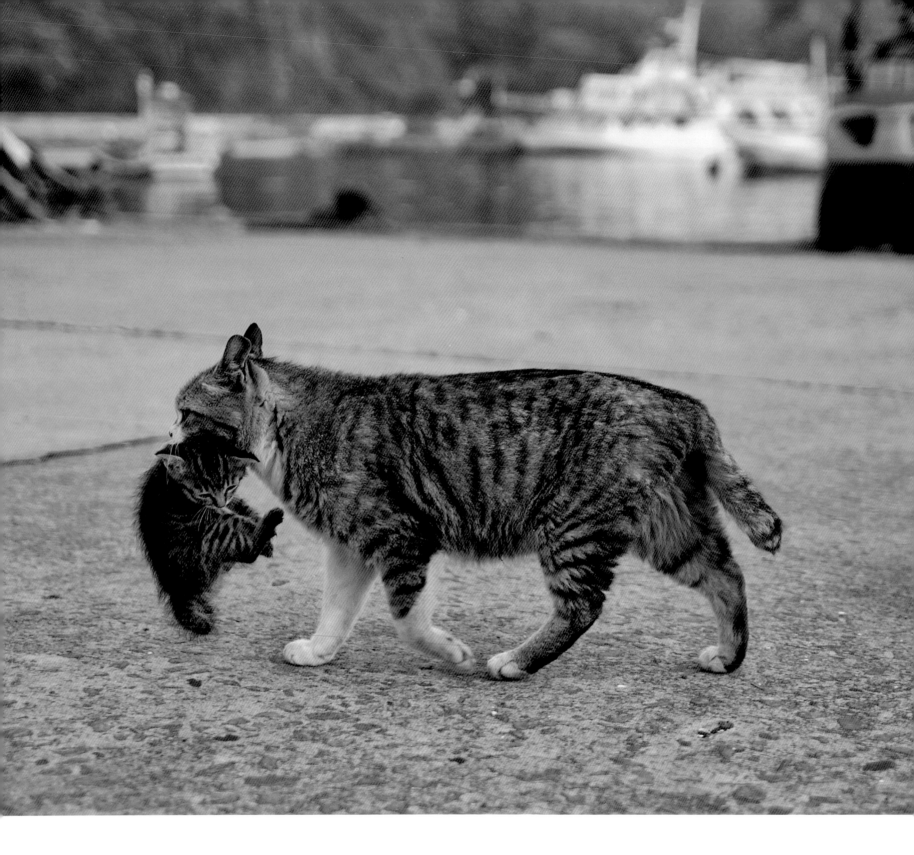

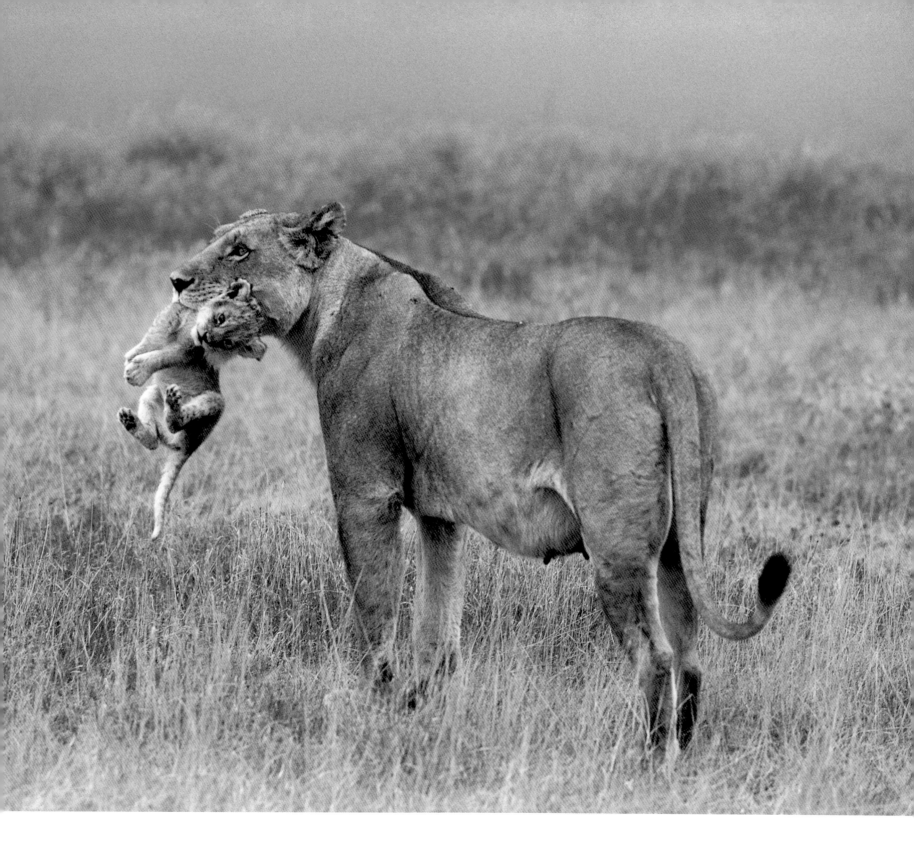

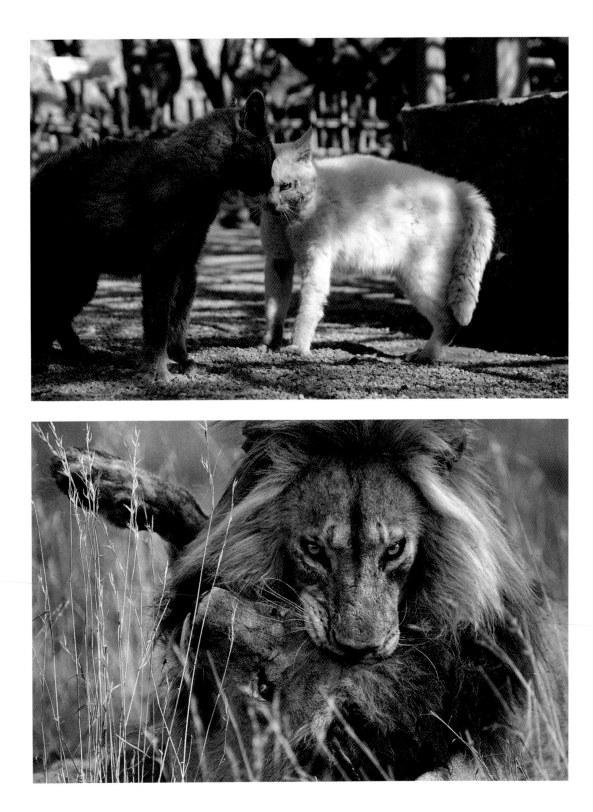

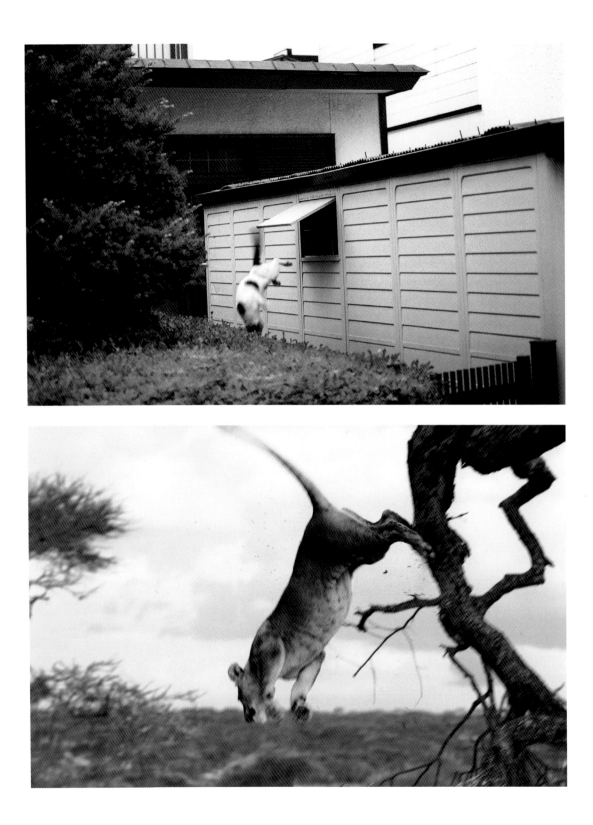

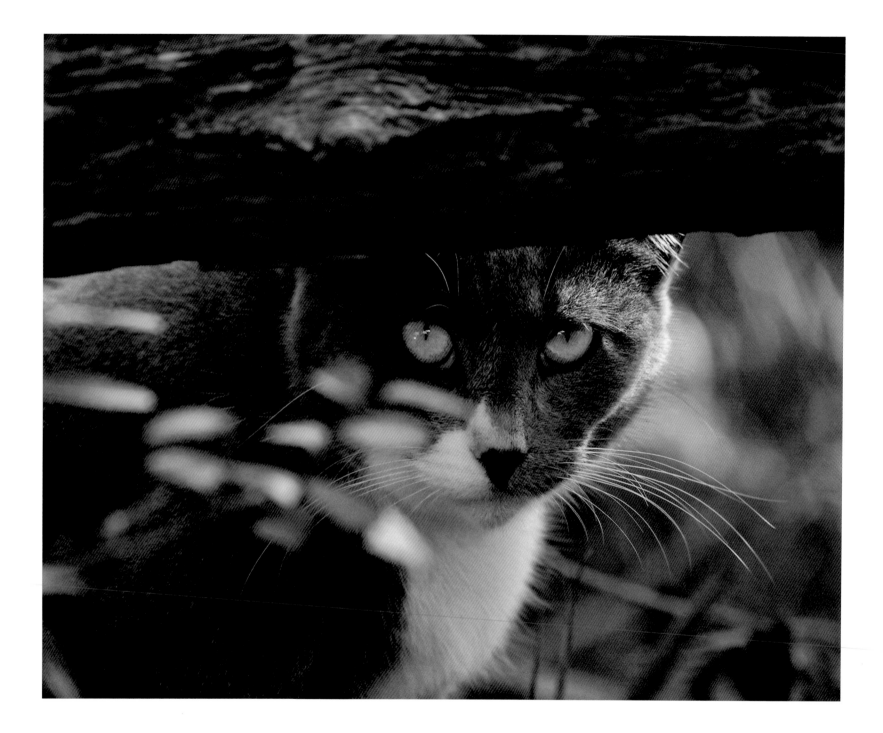

A rest from the hunt.

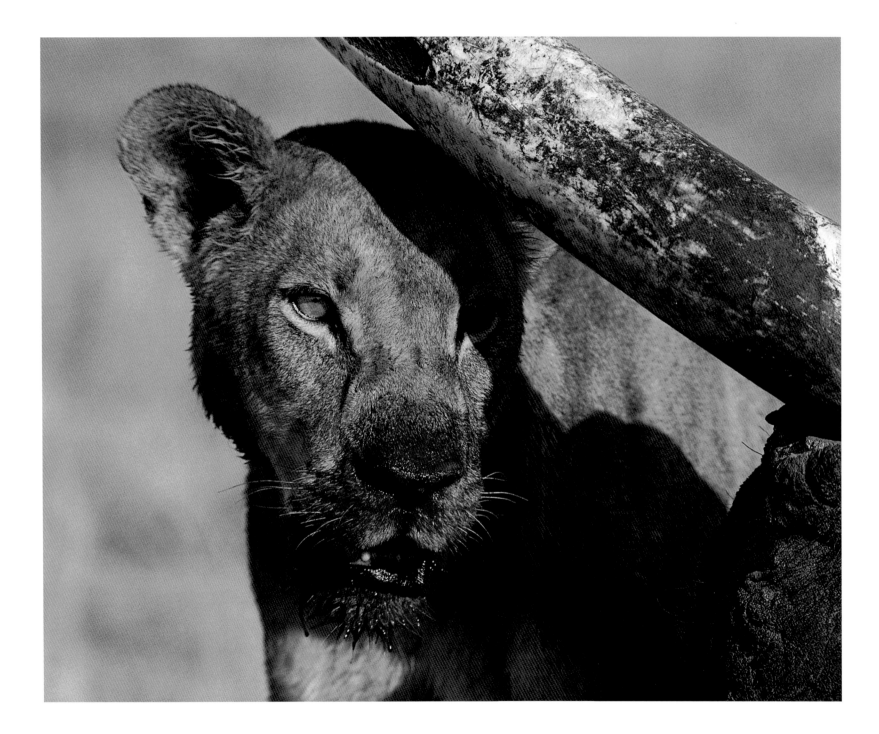

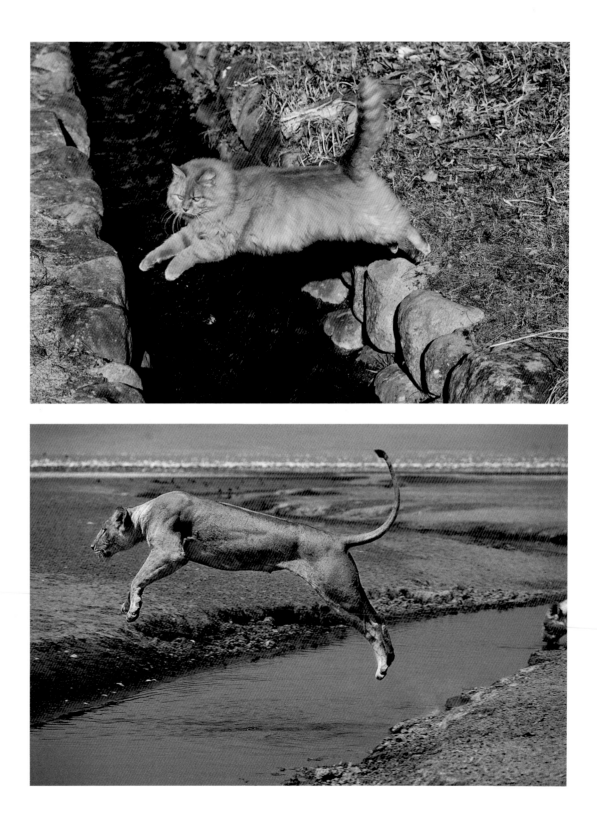

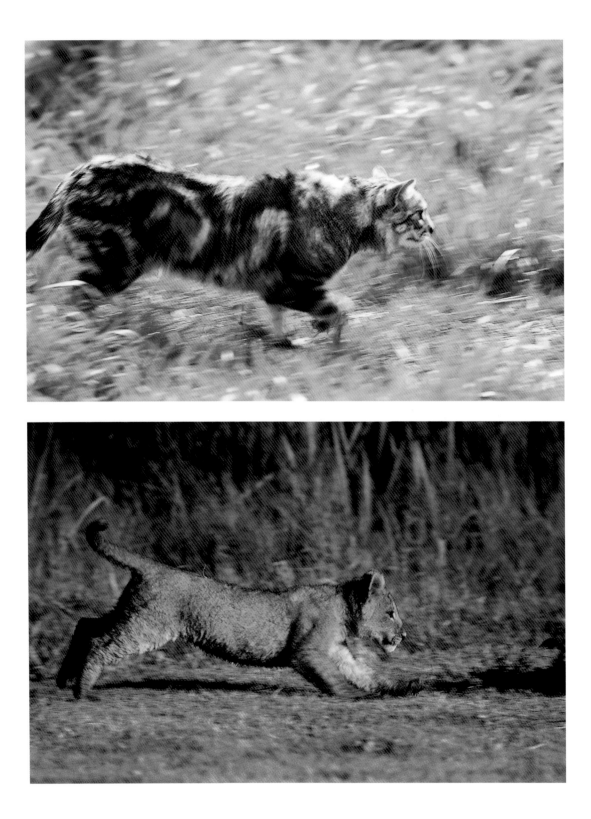

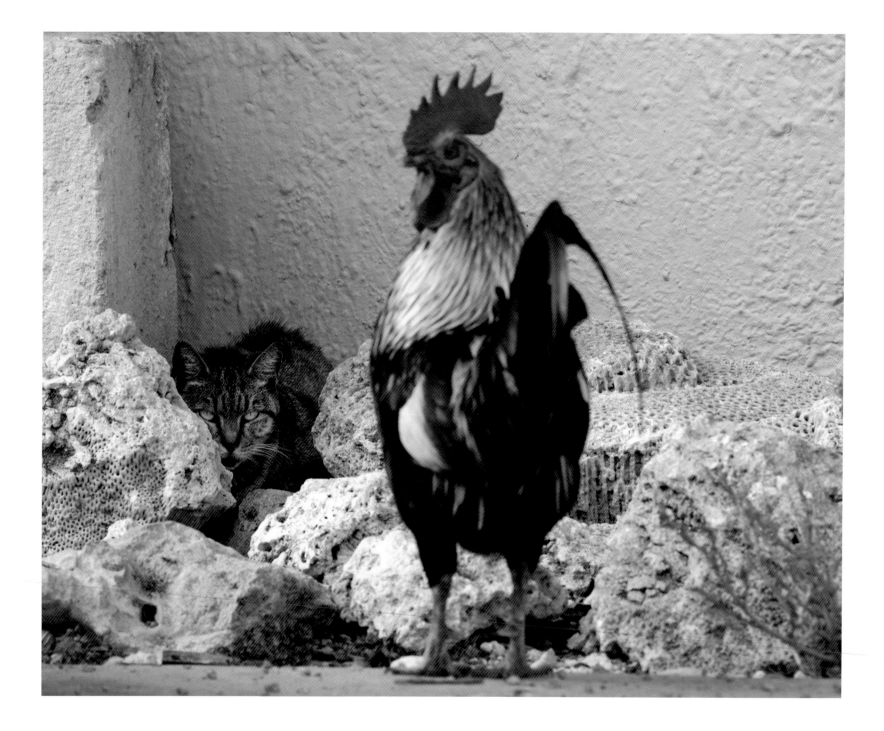

Careful observation is key.

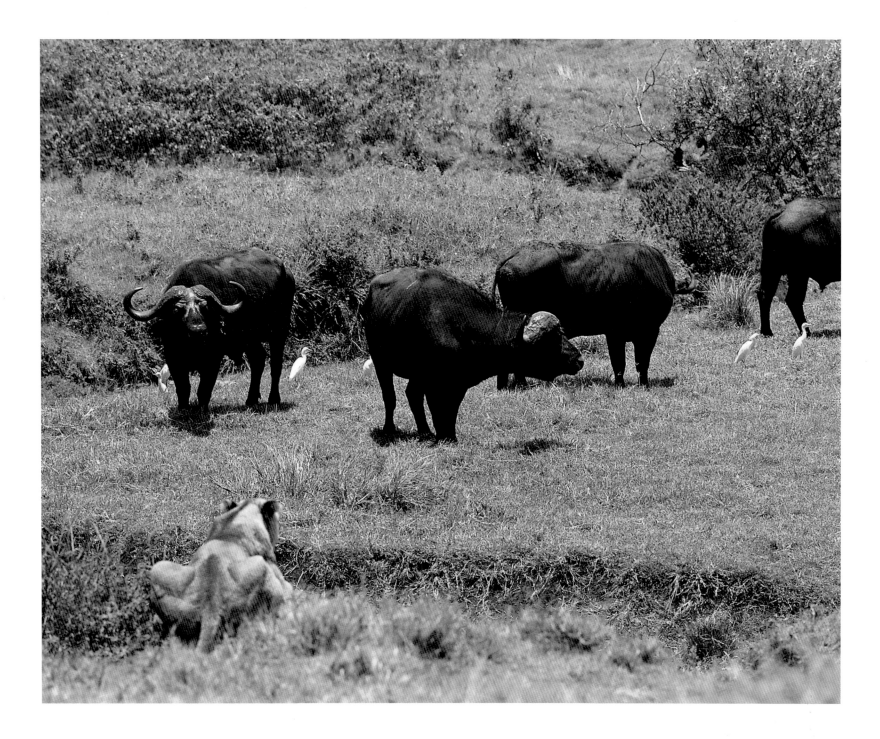

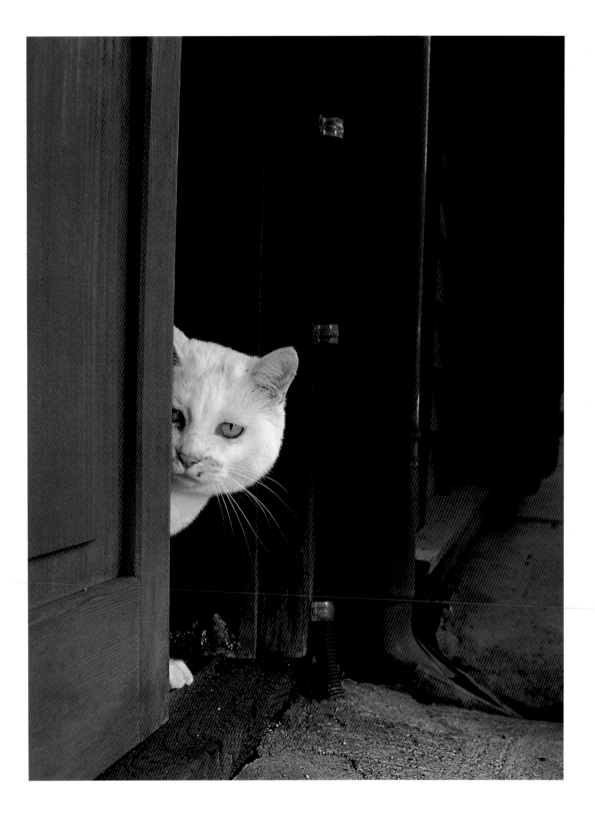

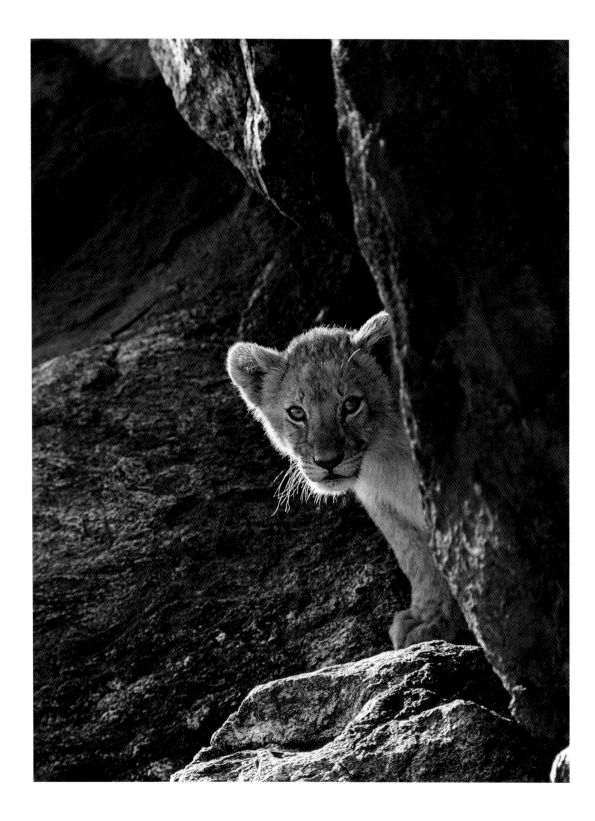

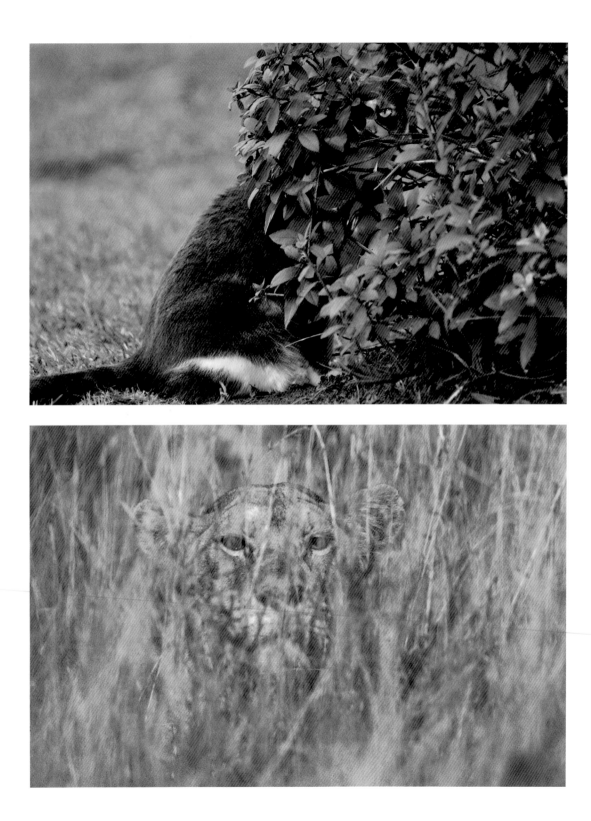

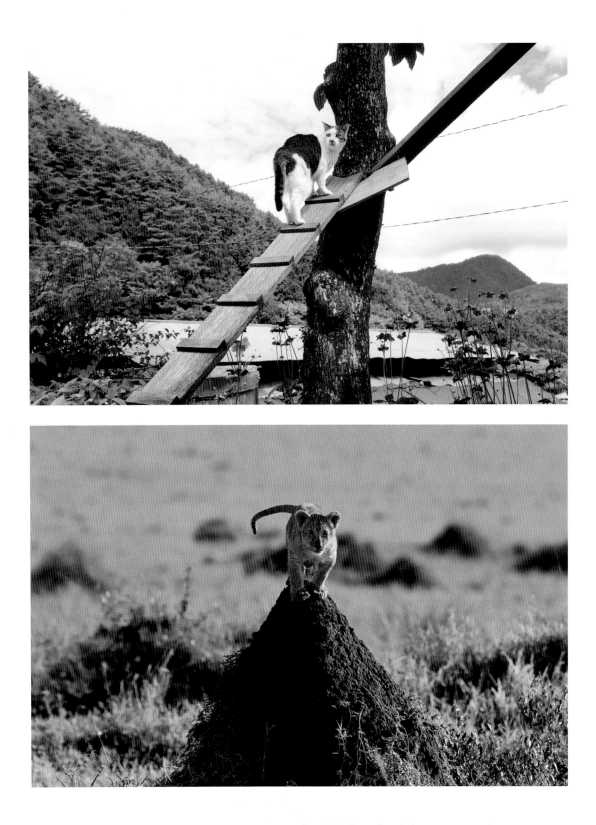

Finding the right vantage point.

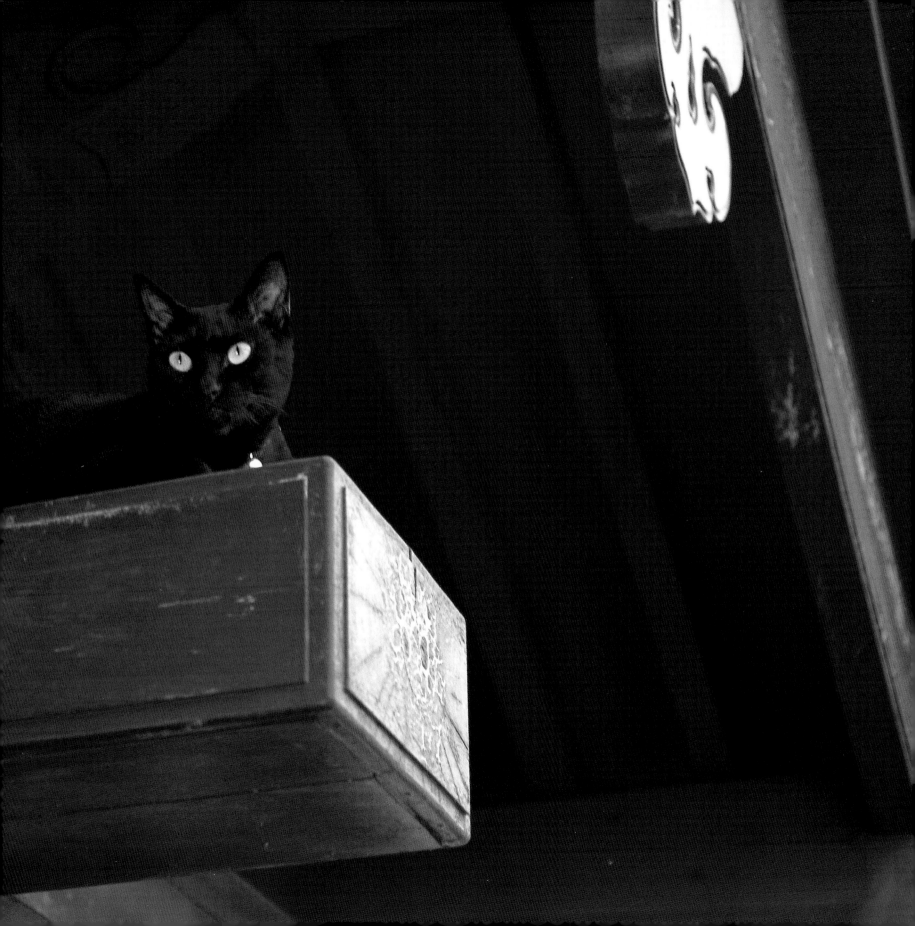

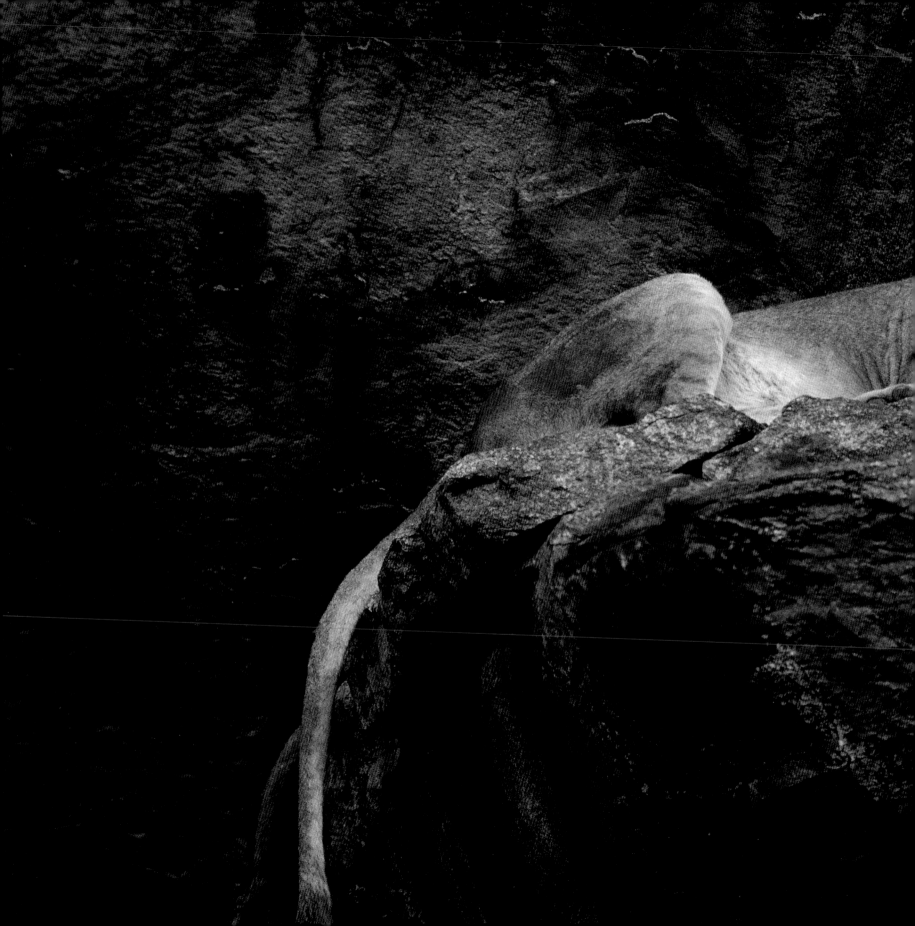

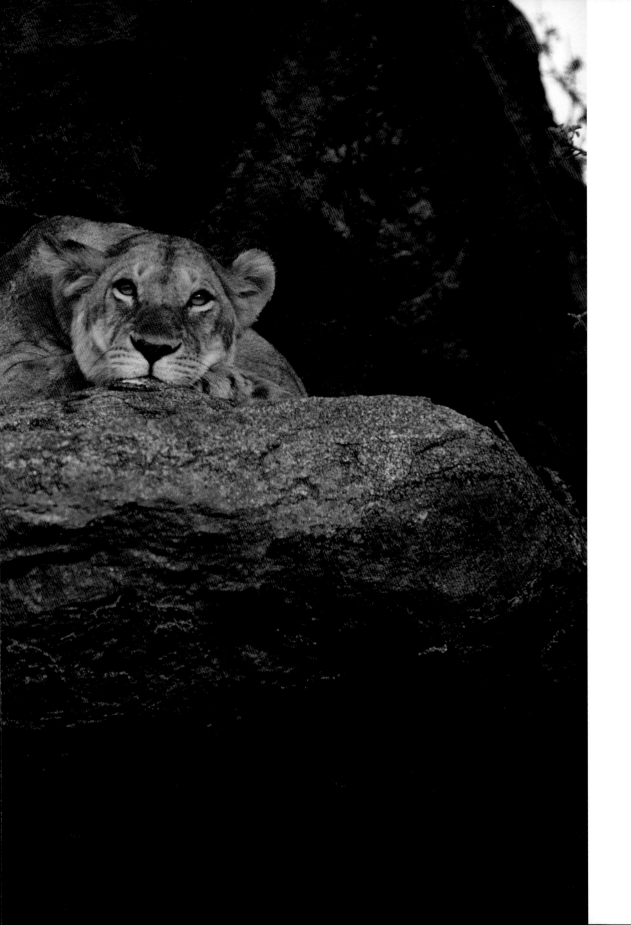

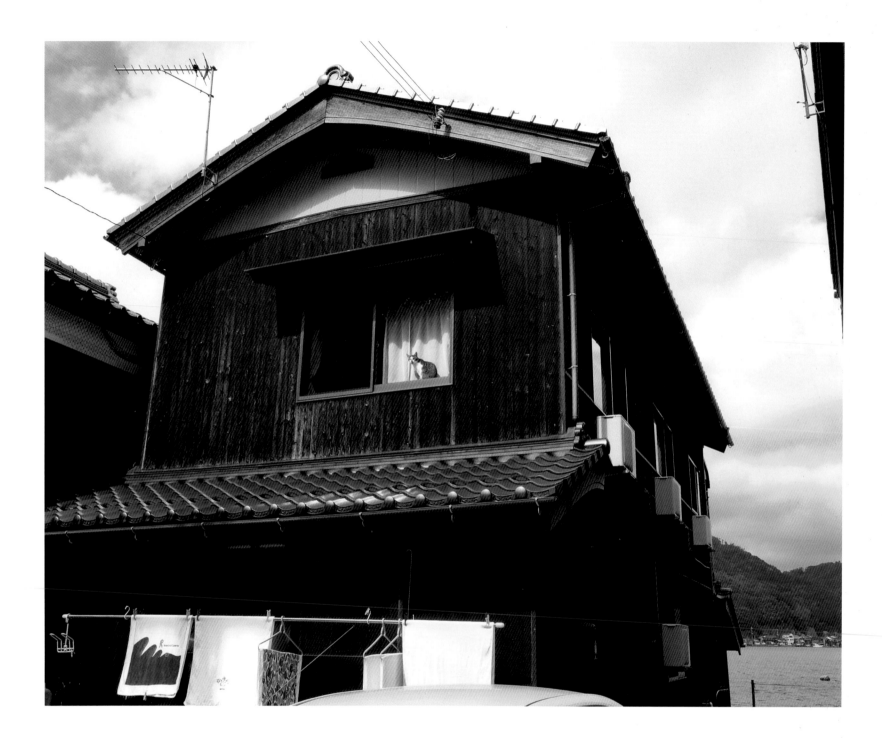

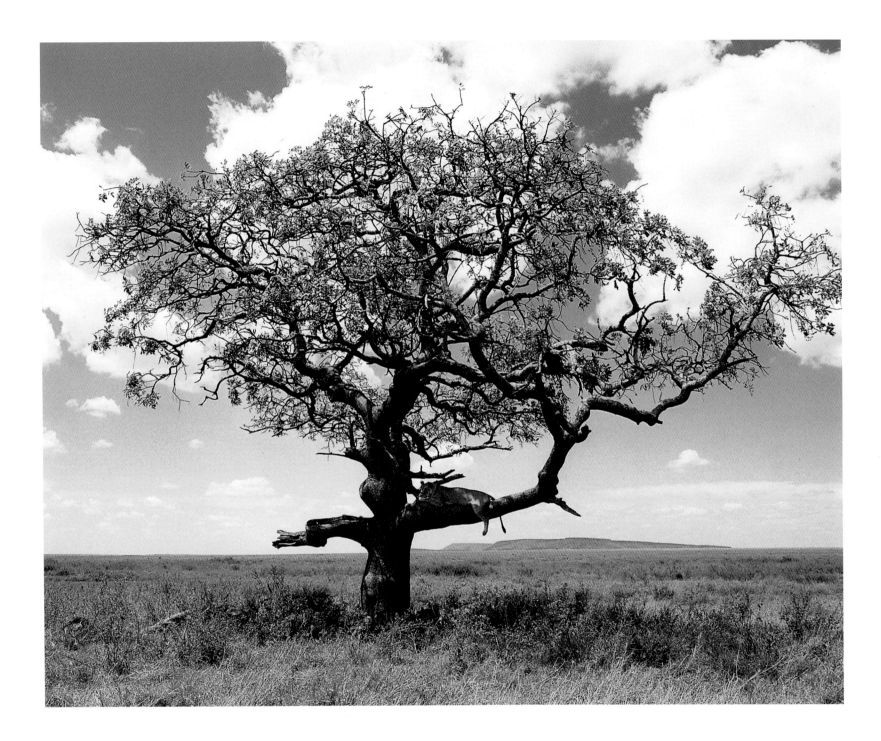

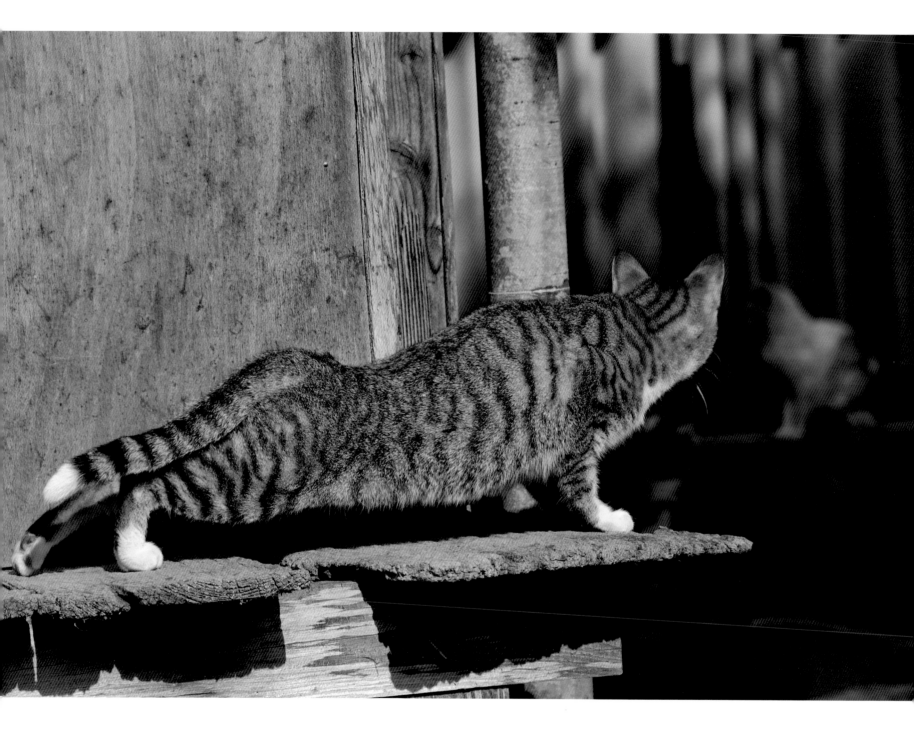

A good stretch.

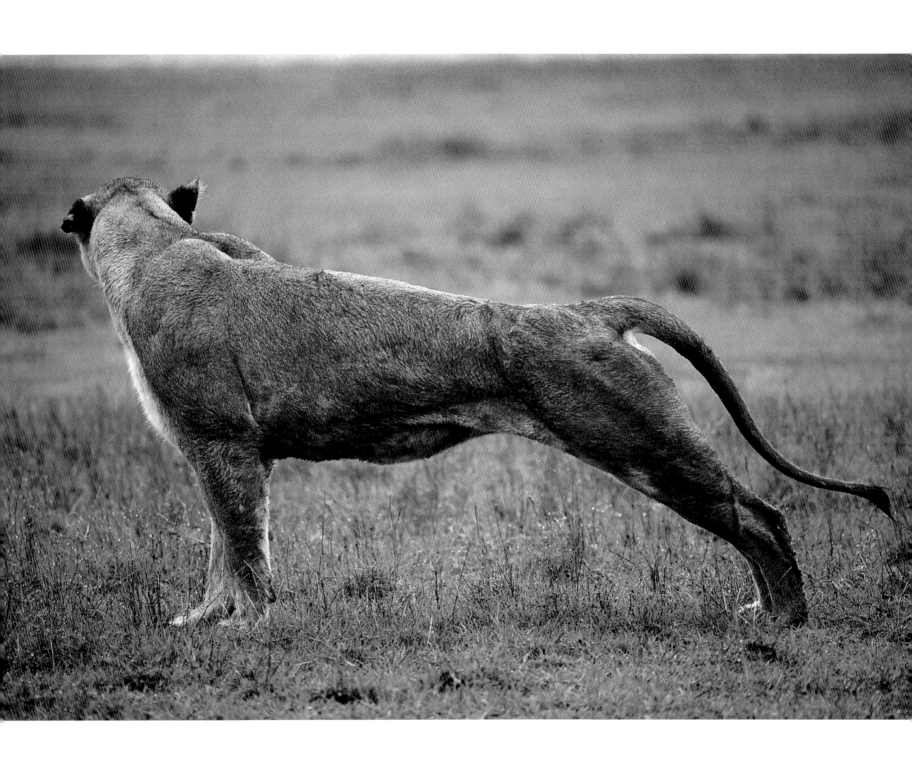

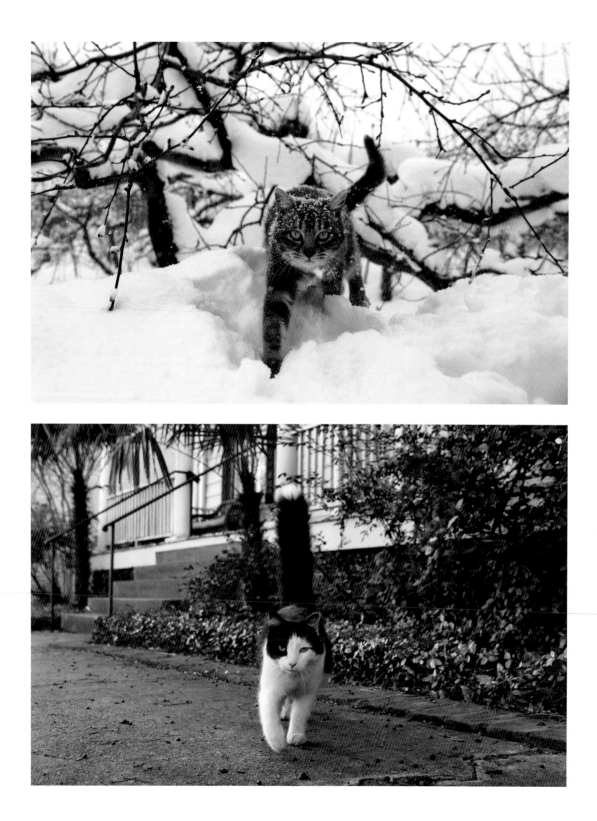

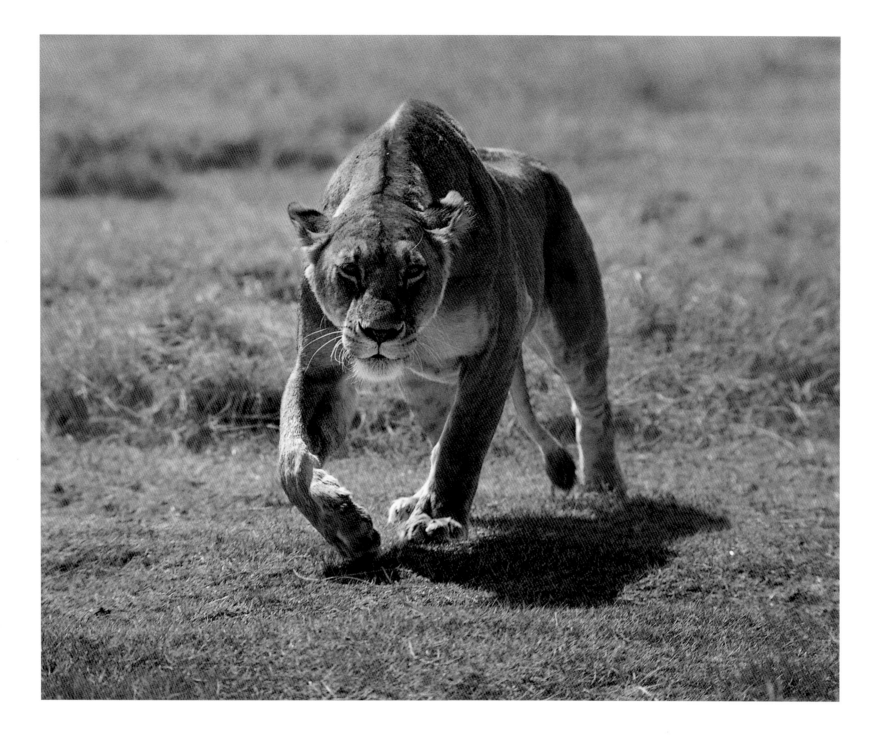

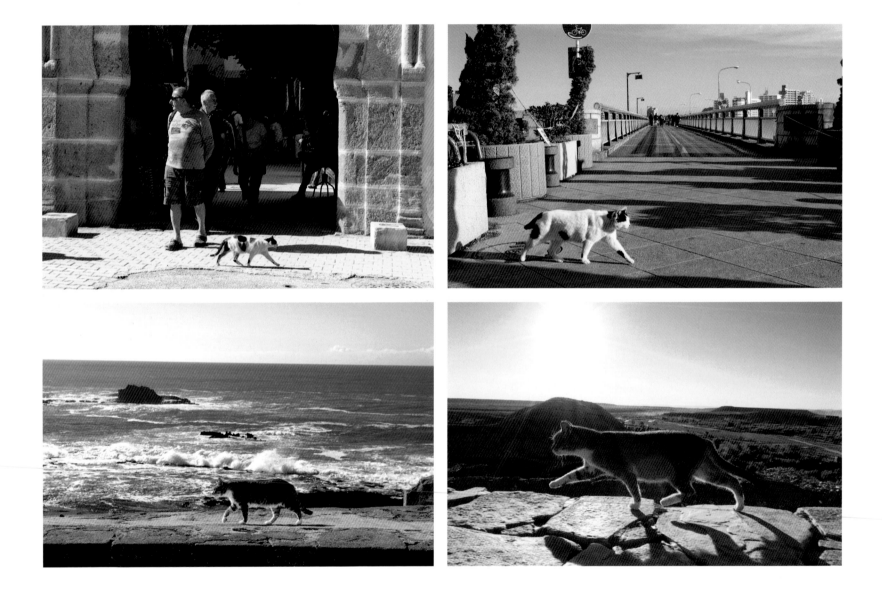

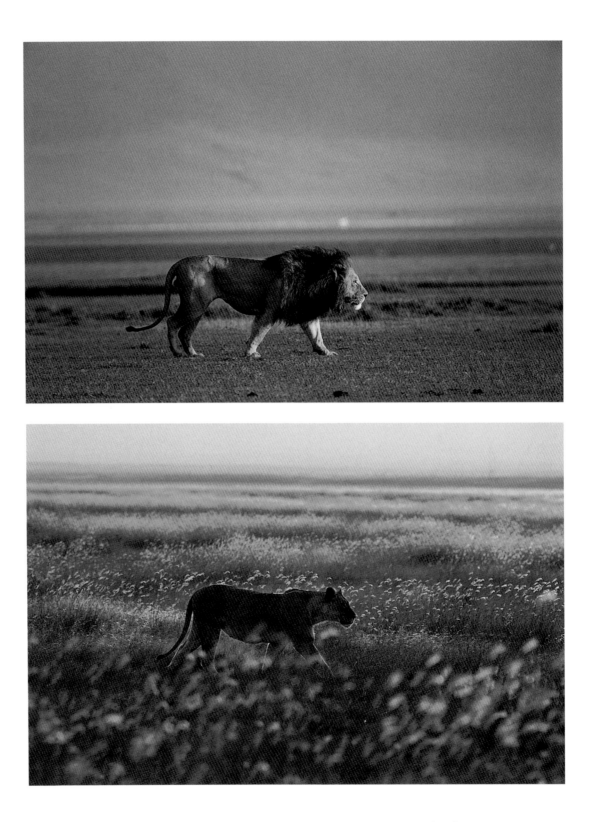

On the move.

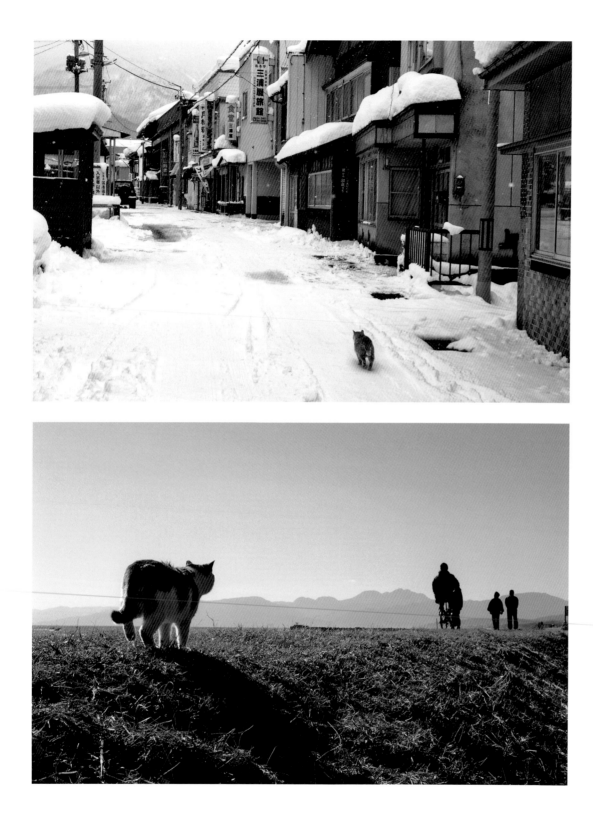

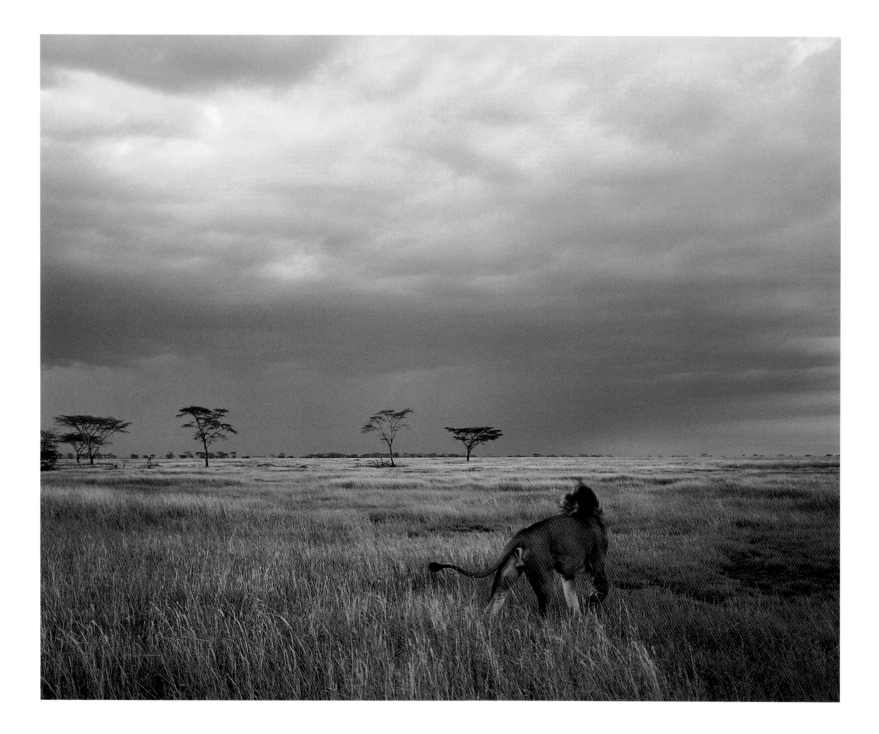

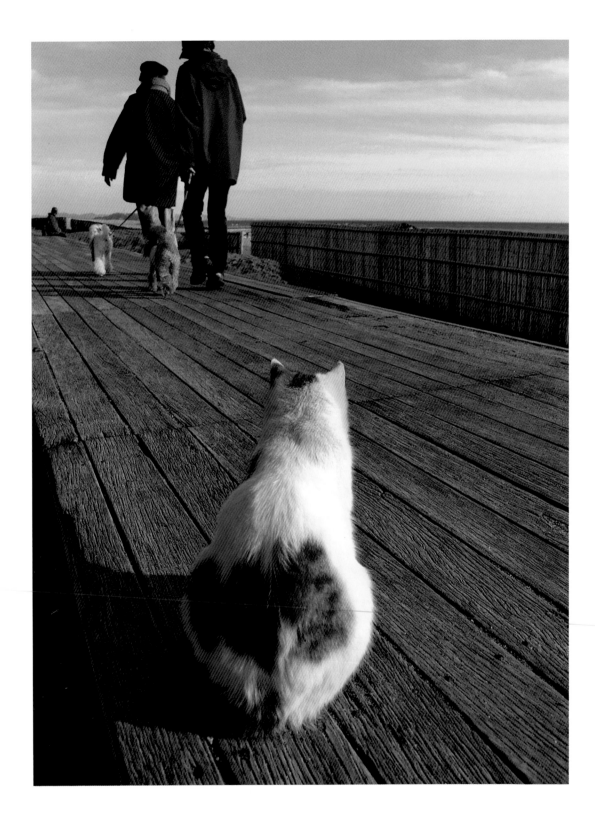

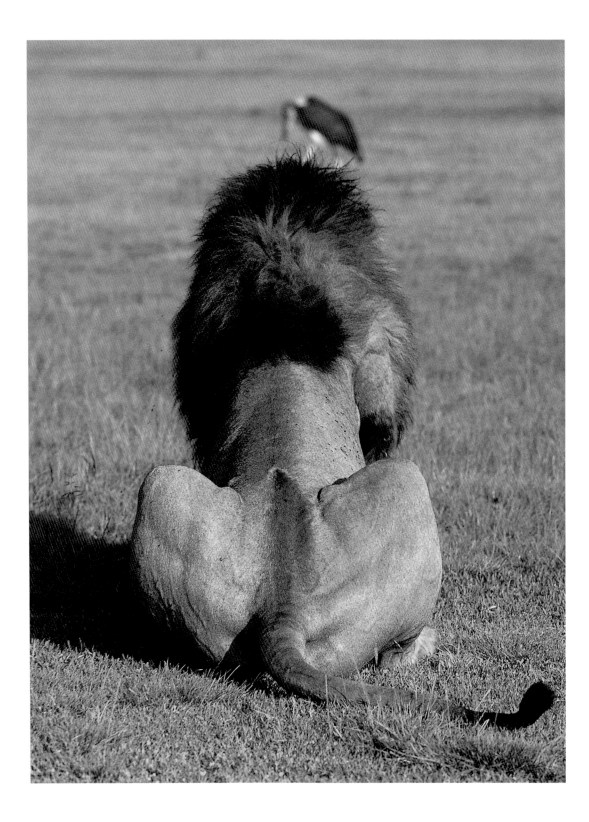

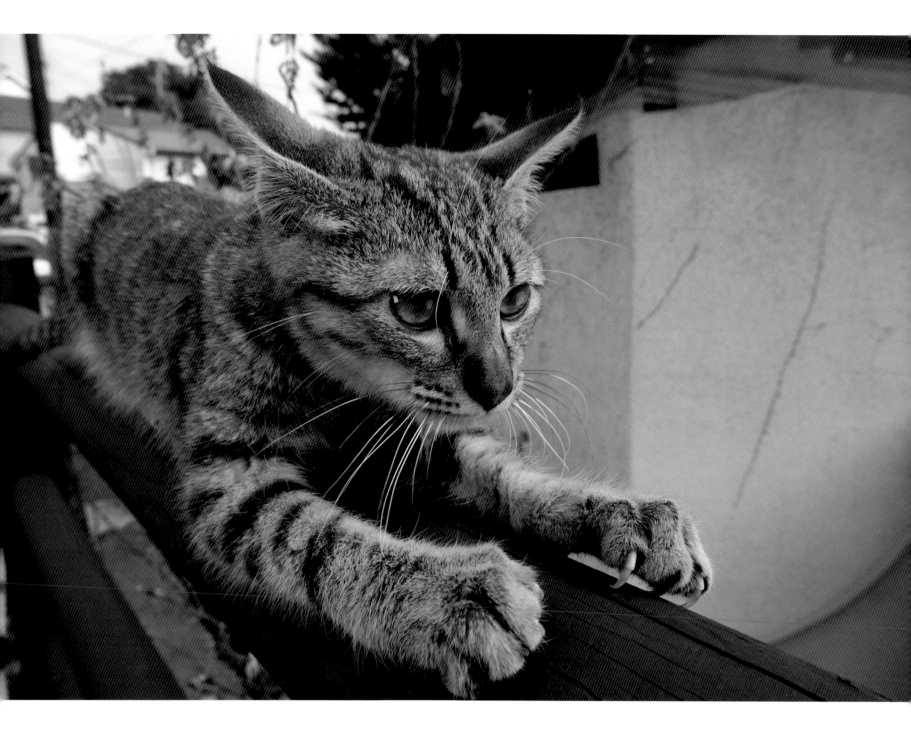

Sharpening the claws.

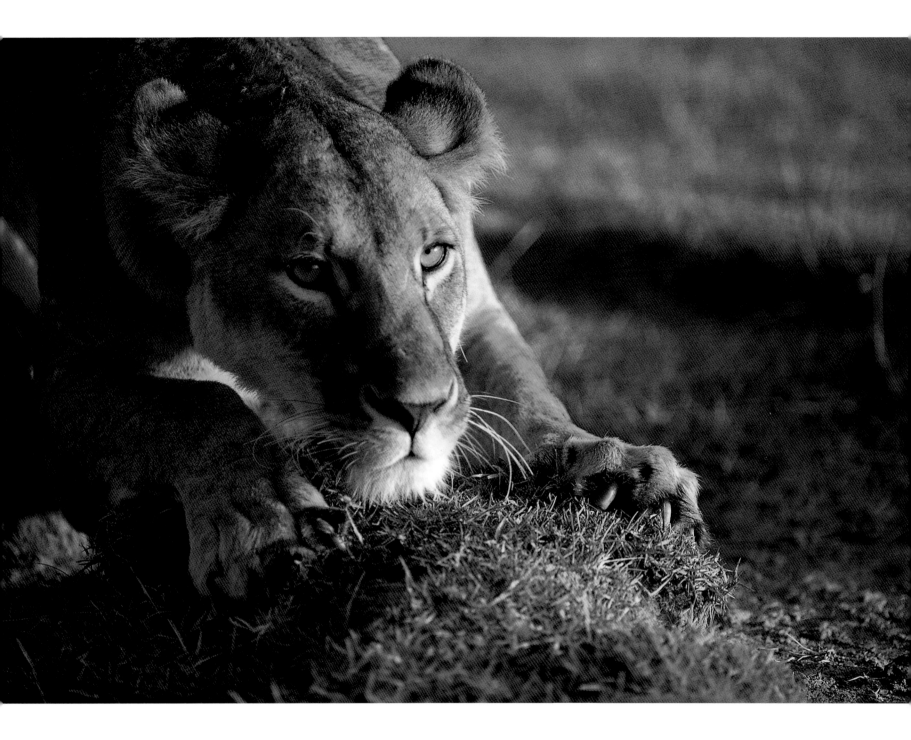

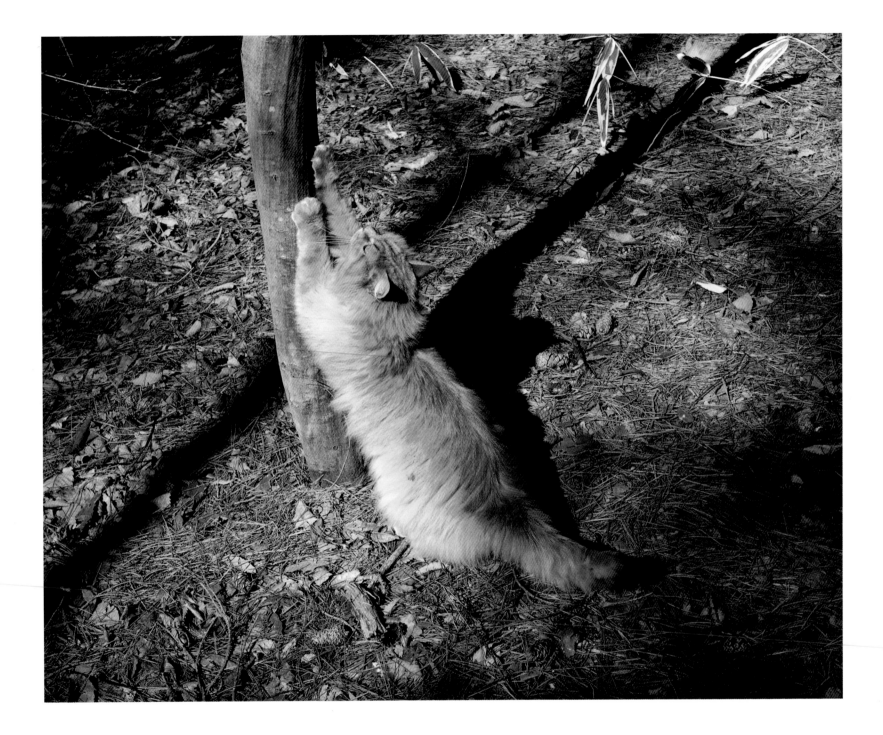

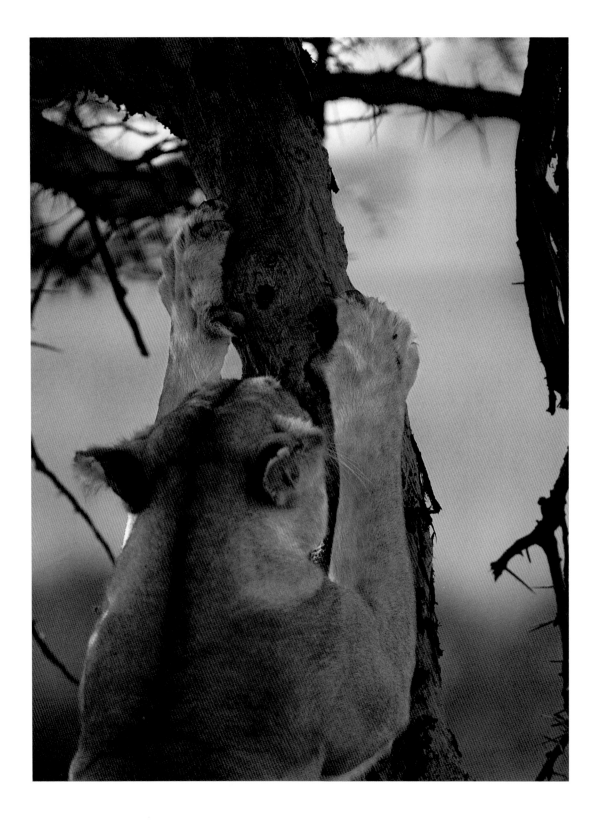

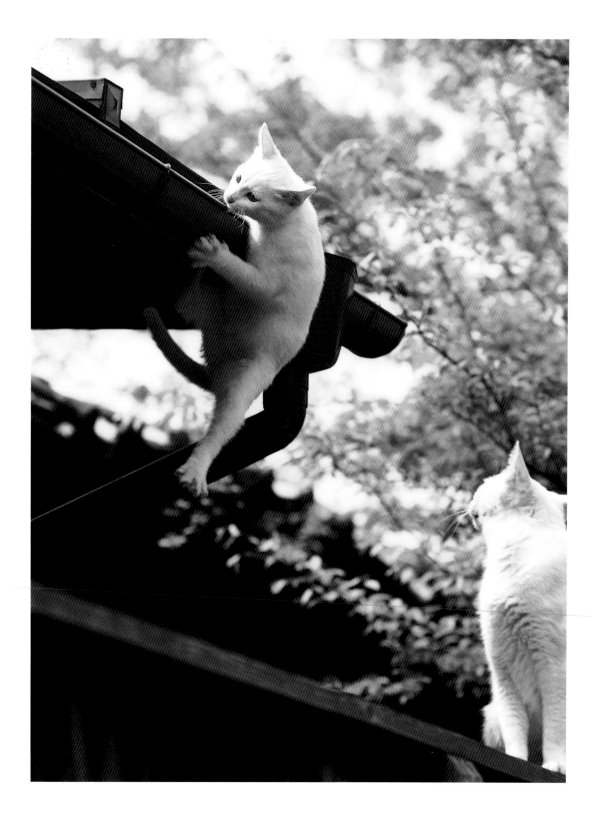

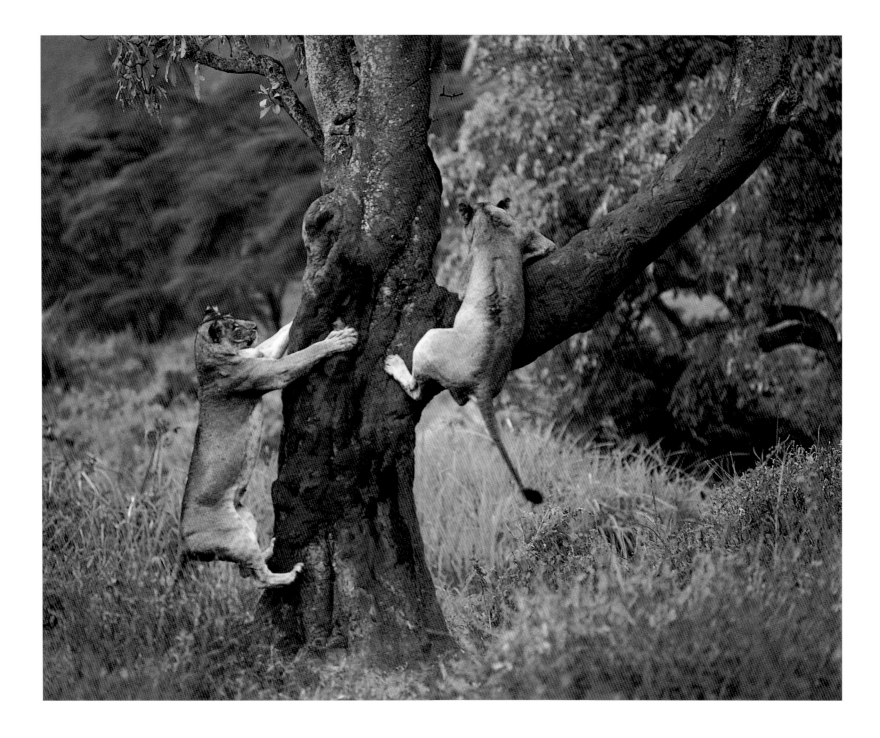

The pleasure and perils of climbing.

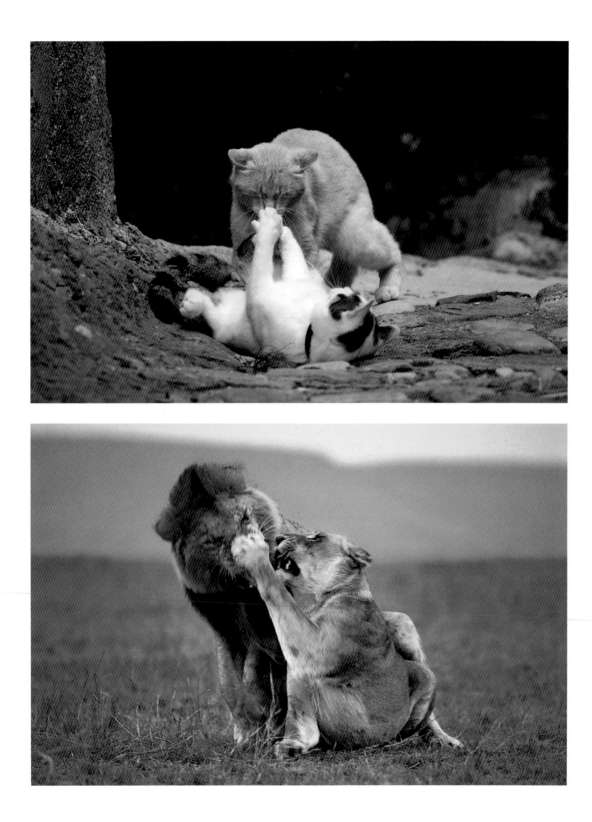

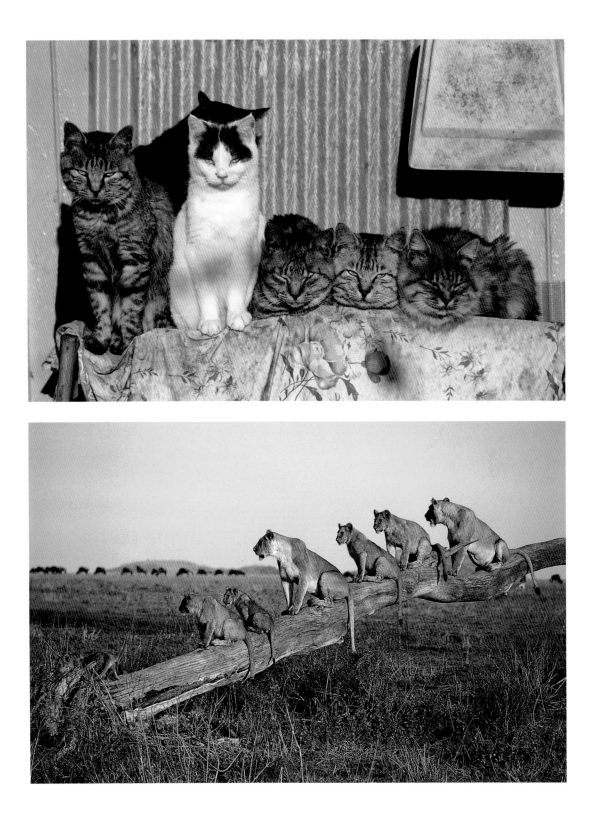

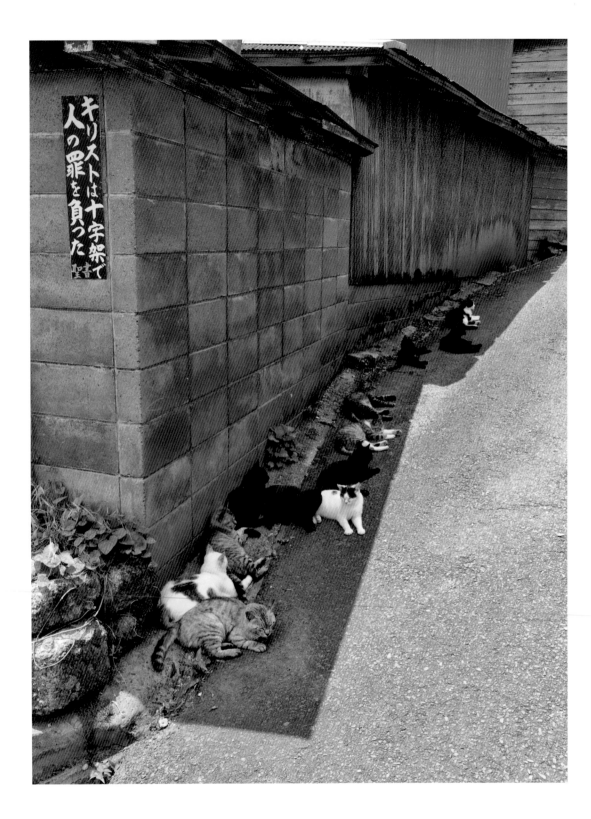

A family gathering.

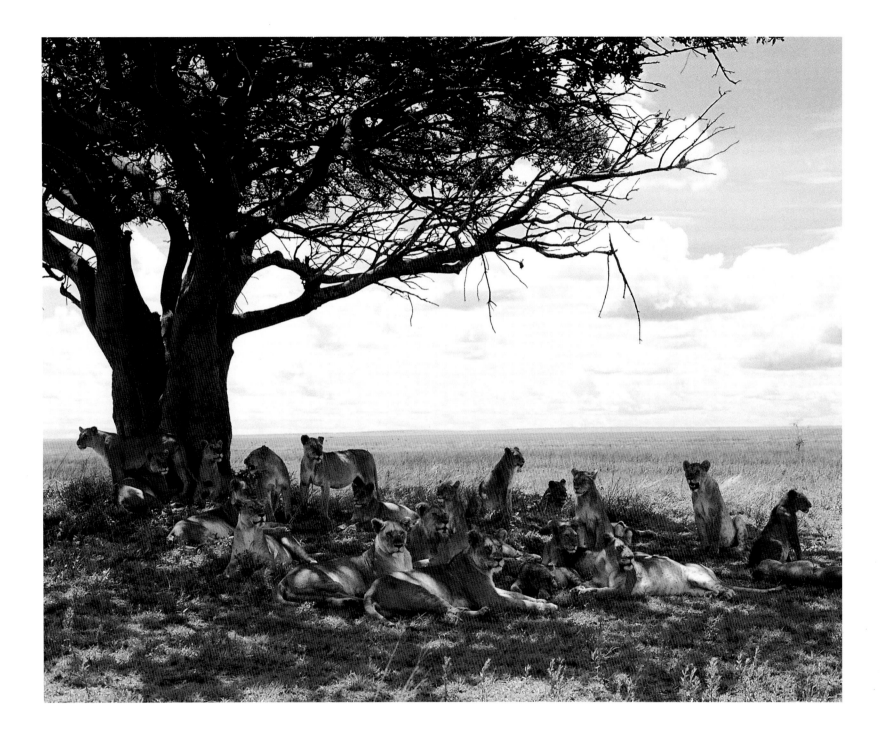

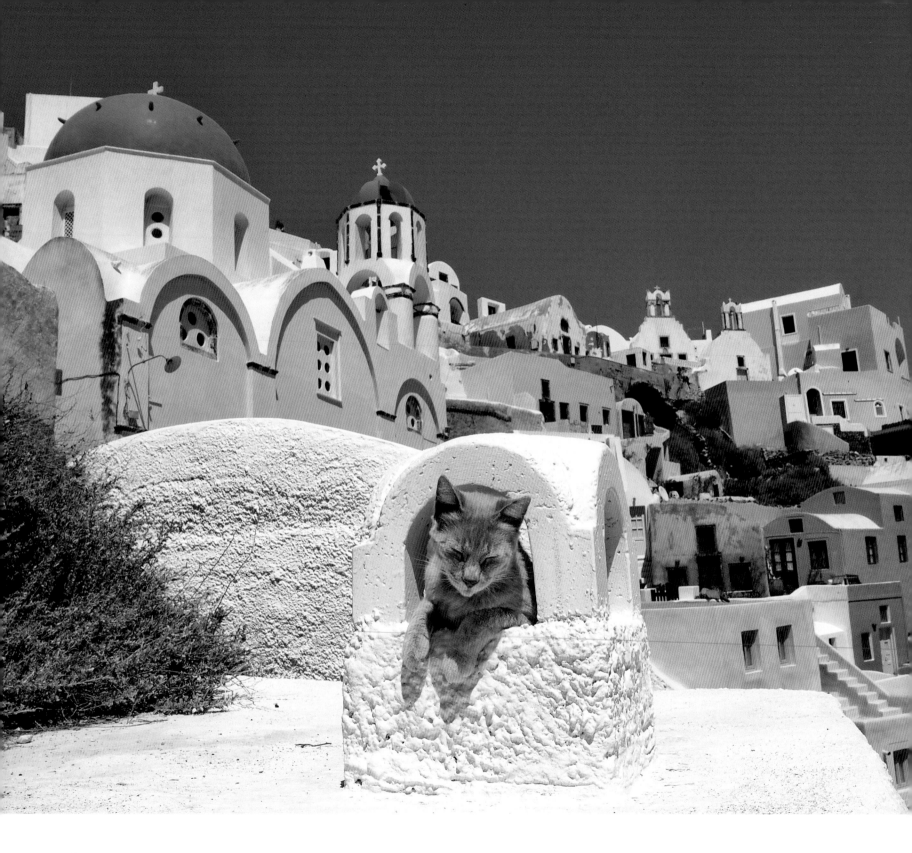

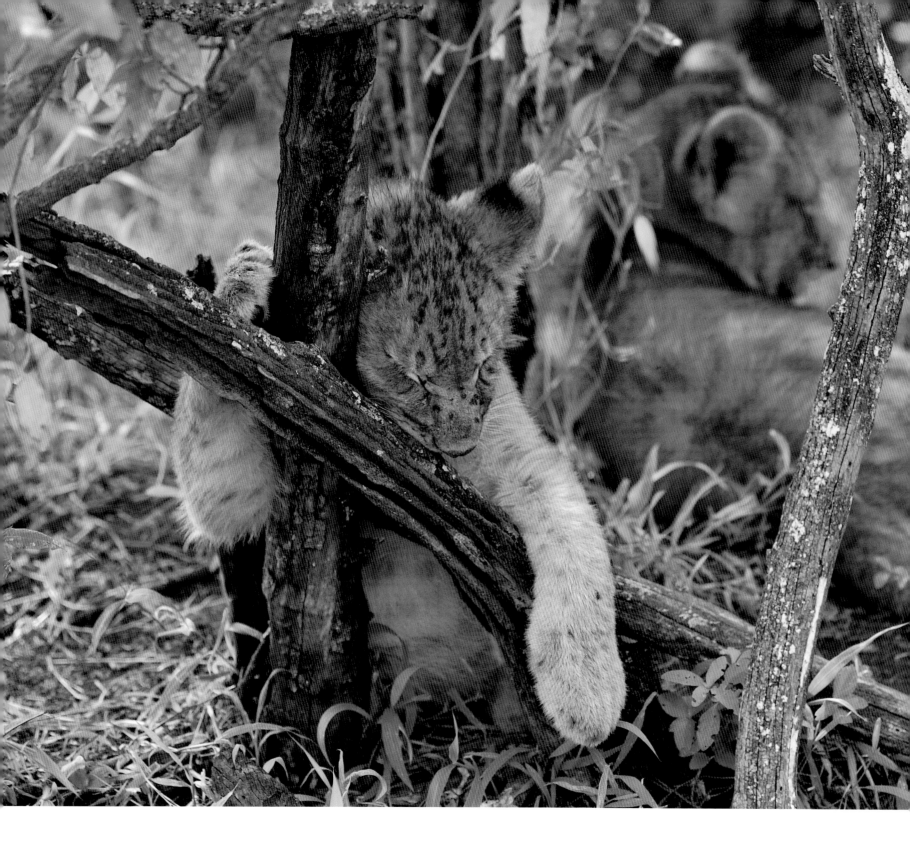

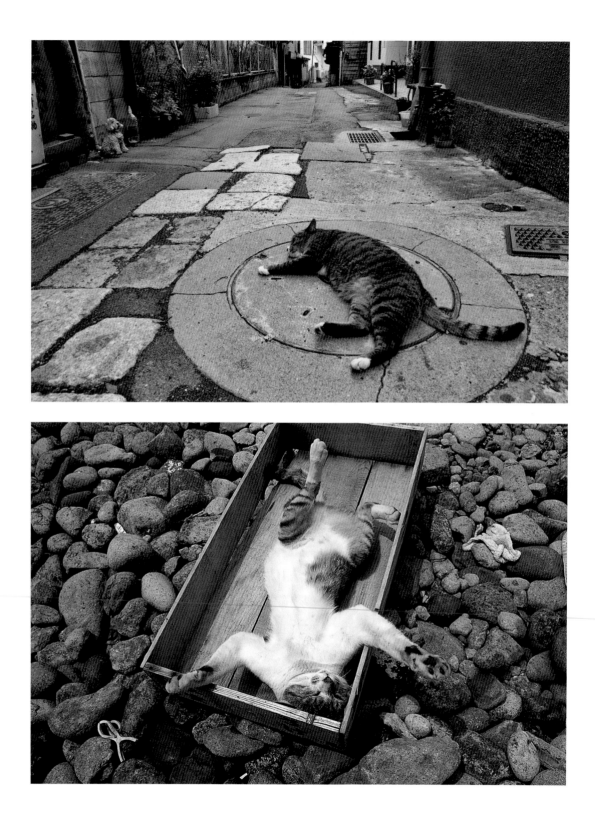

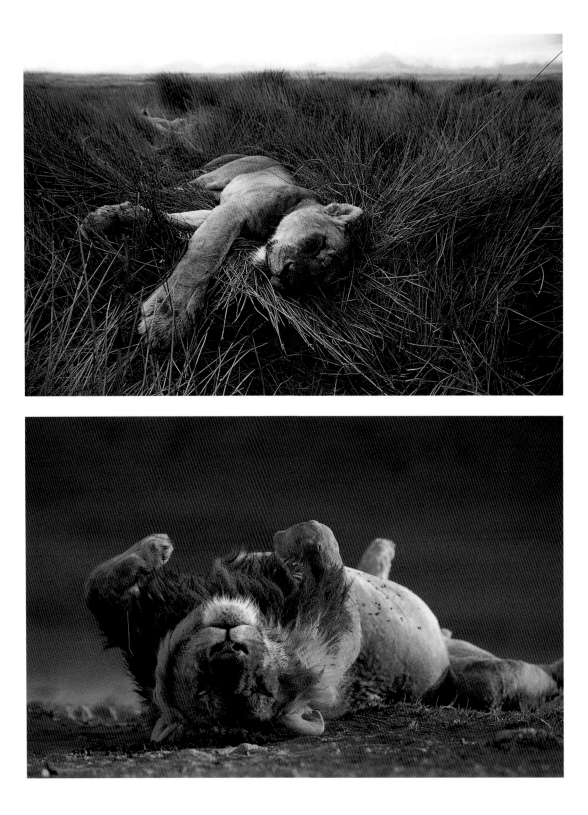

Time for a nap.

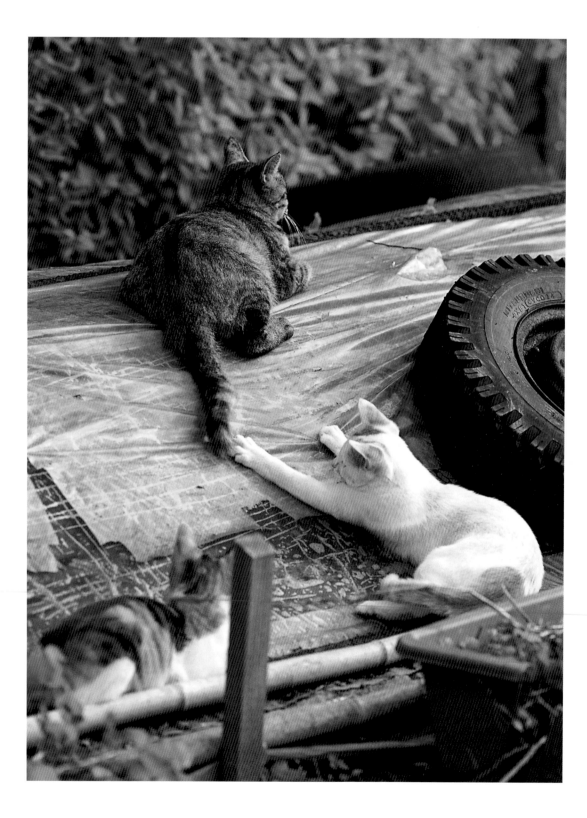

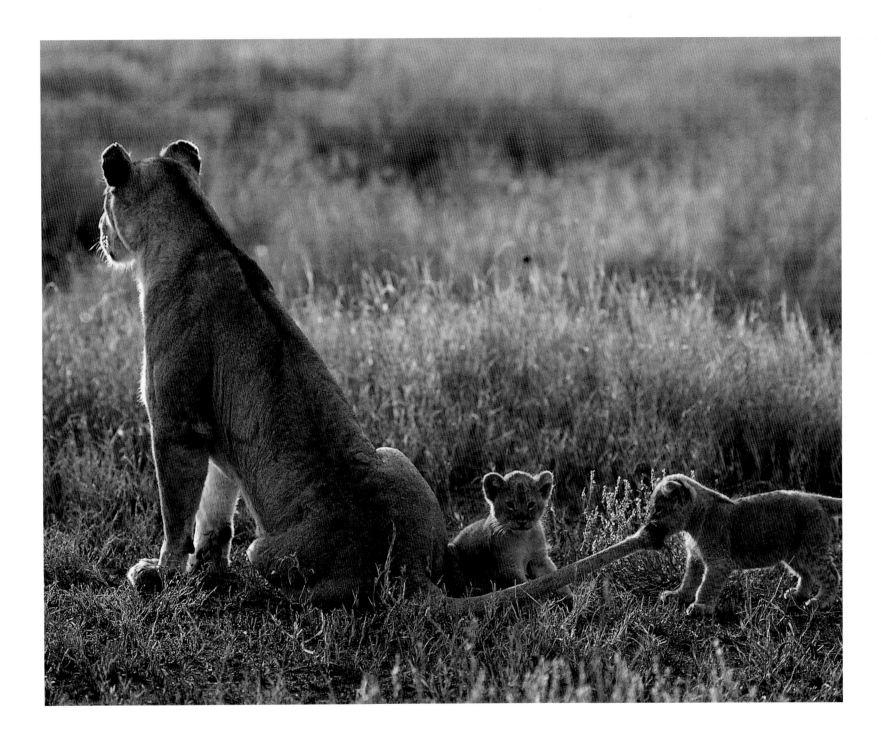

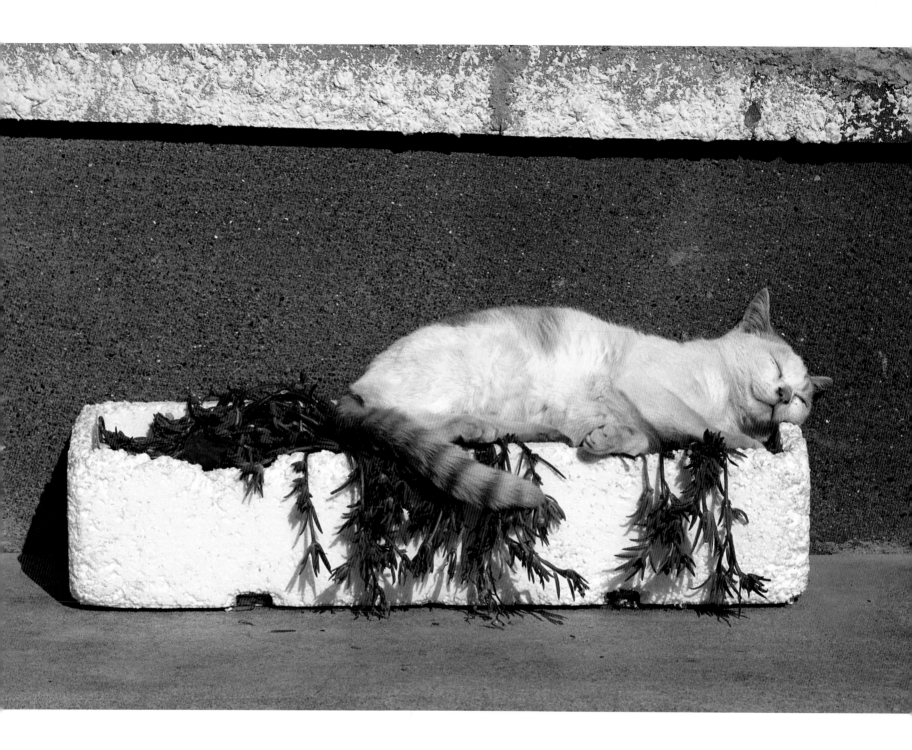

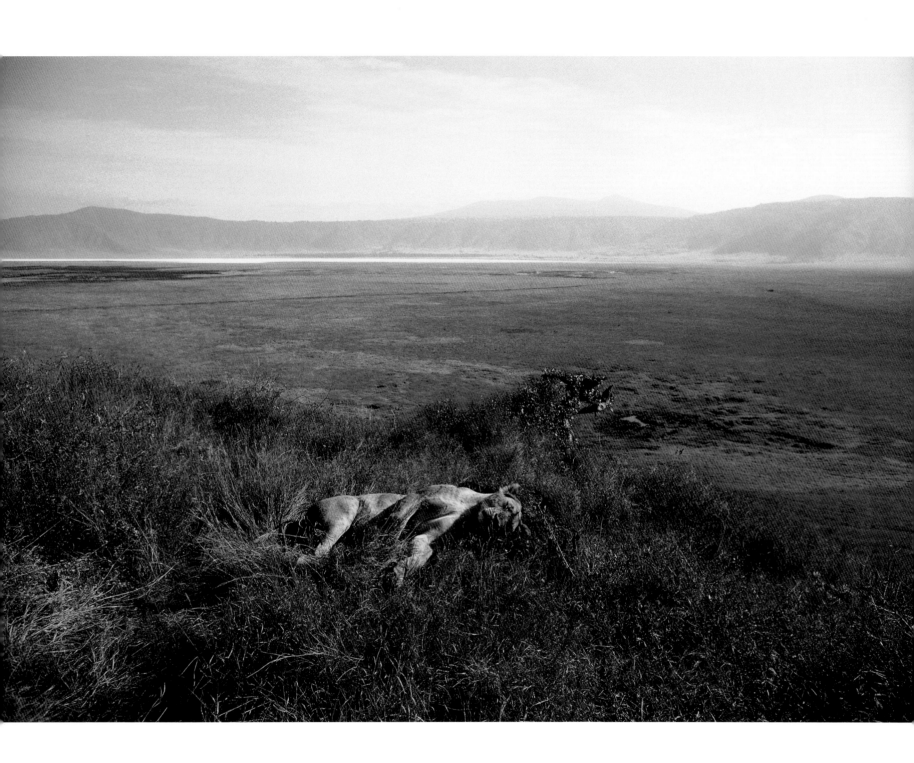

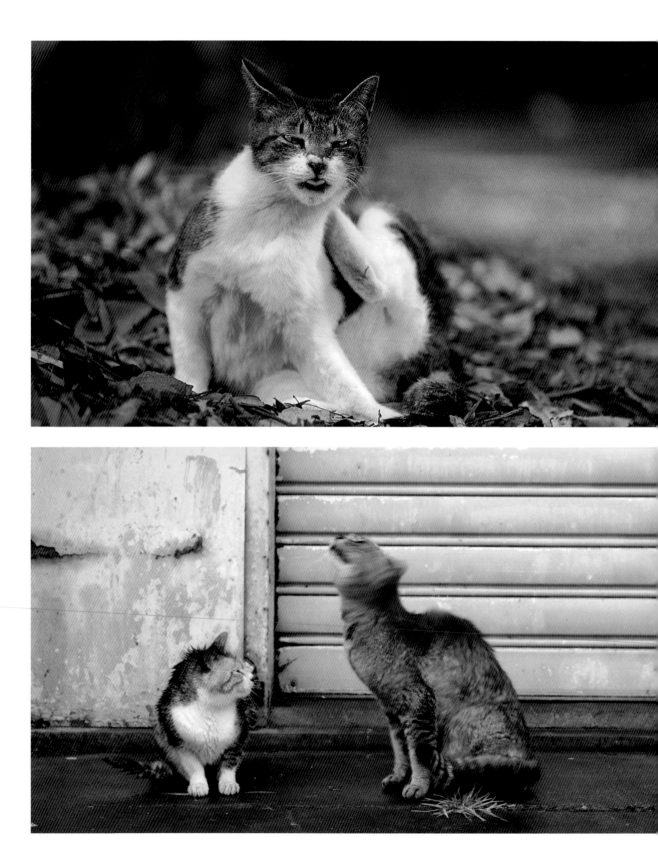

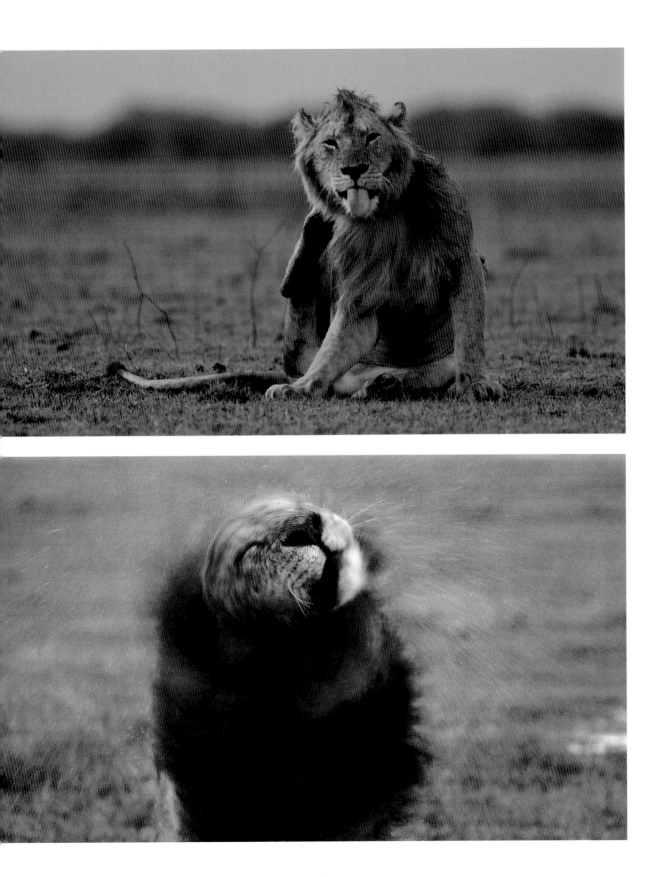

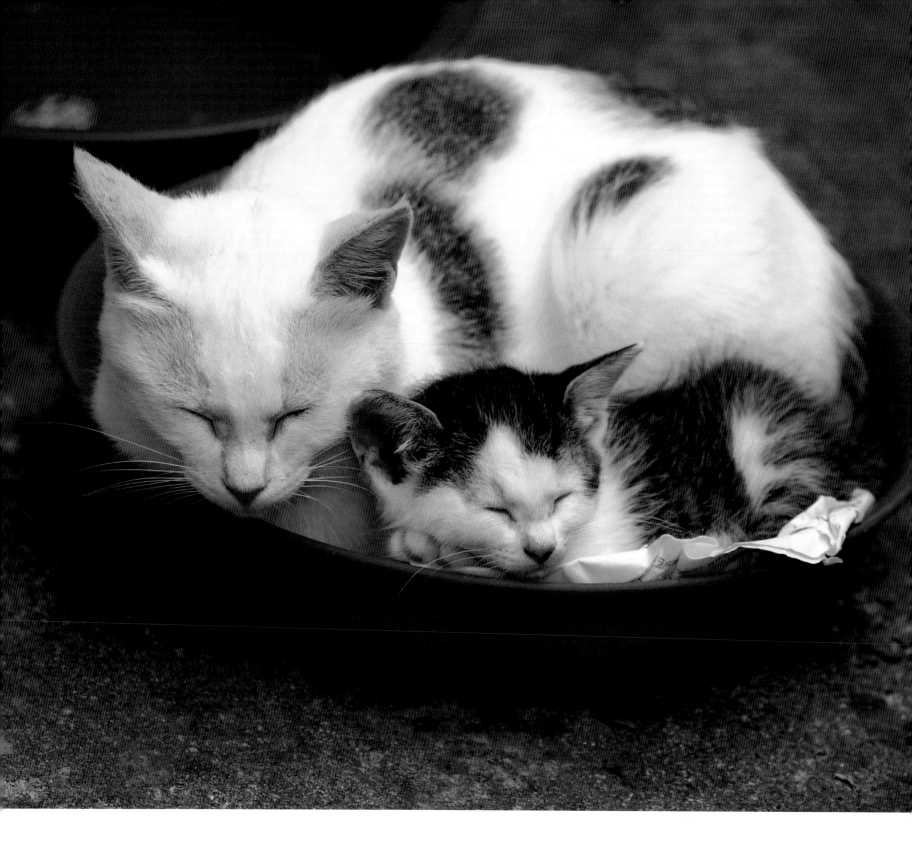

A perfect fit.

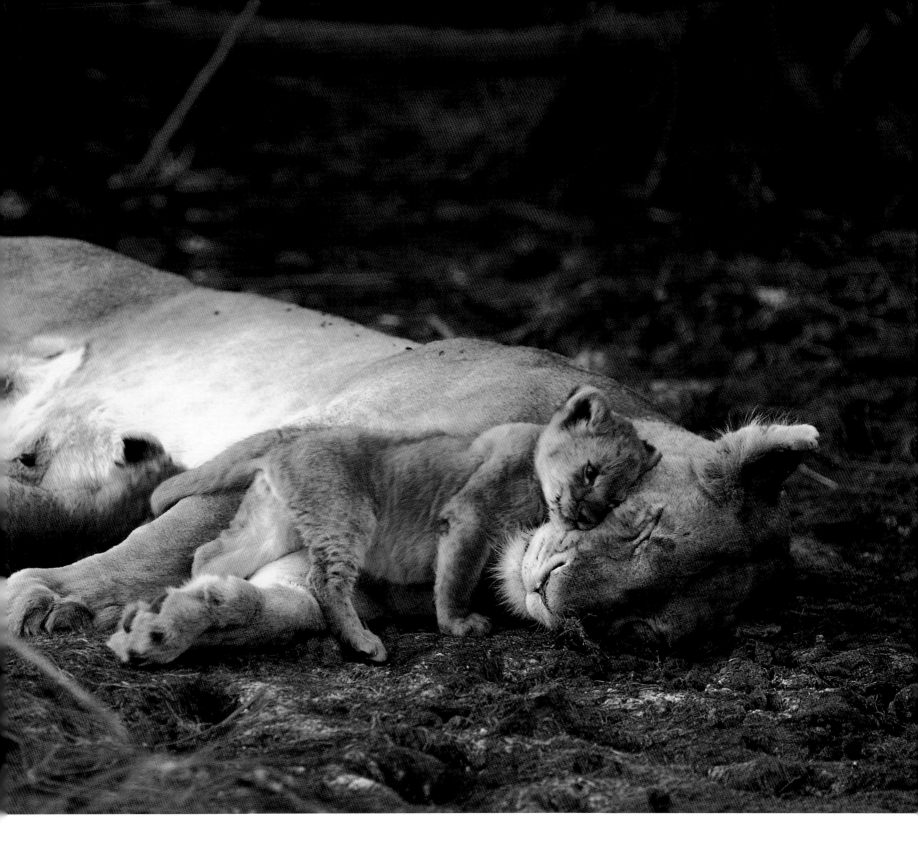

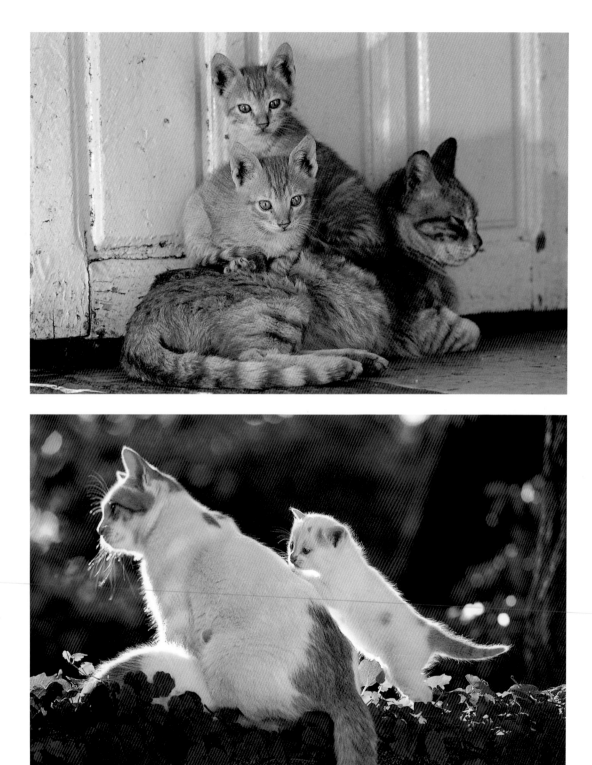

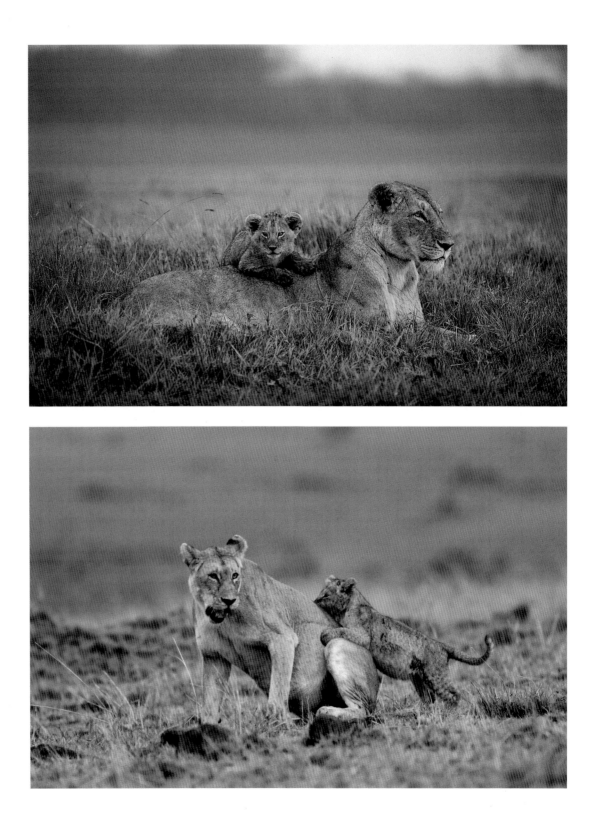

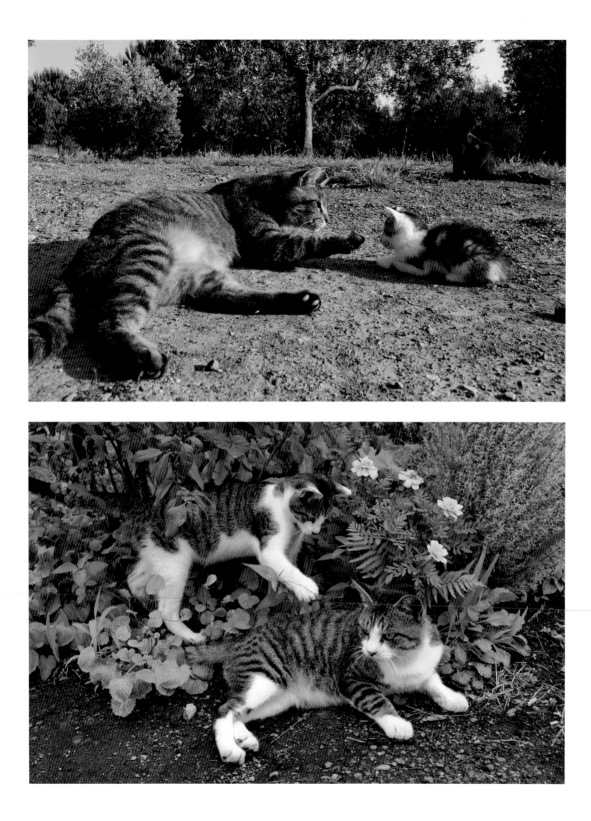

Reaching out.

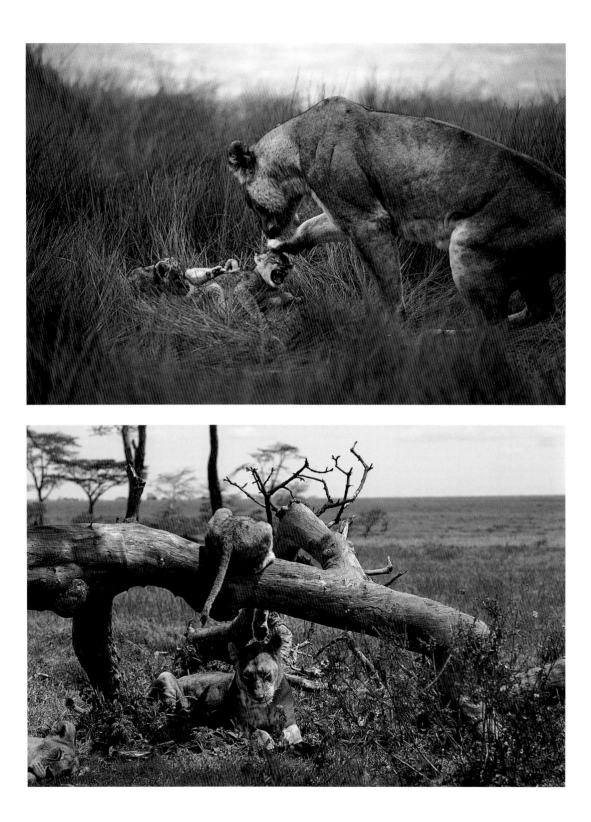

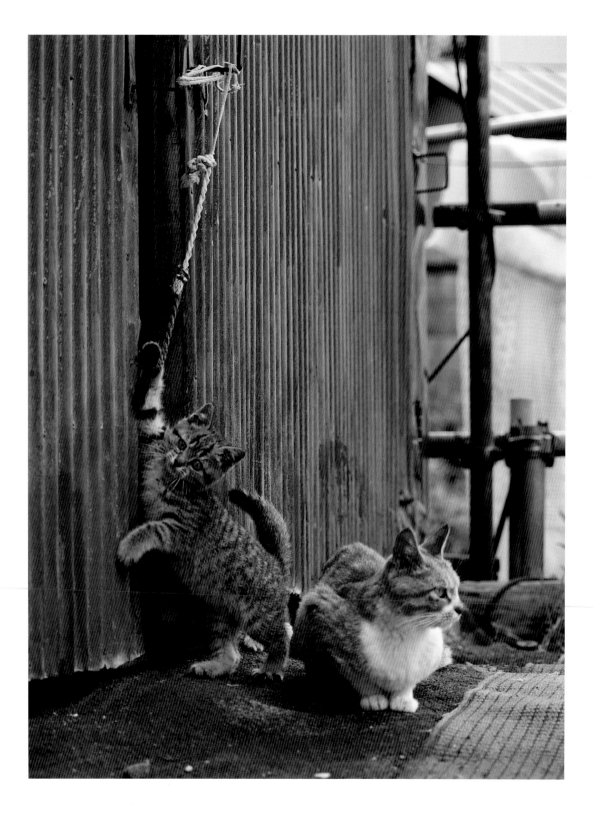

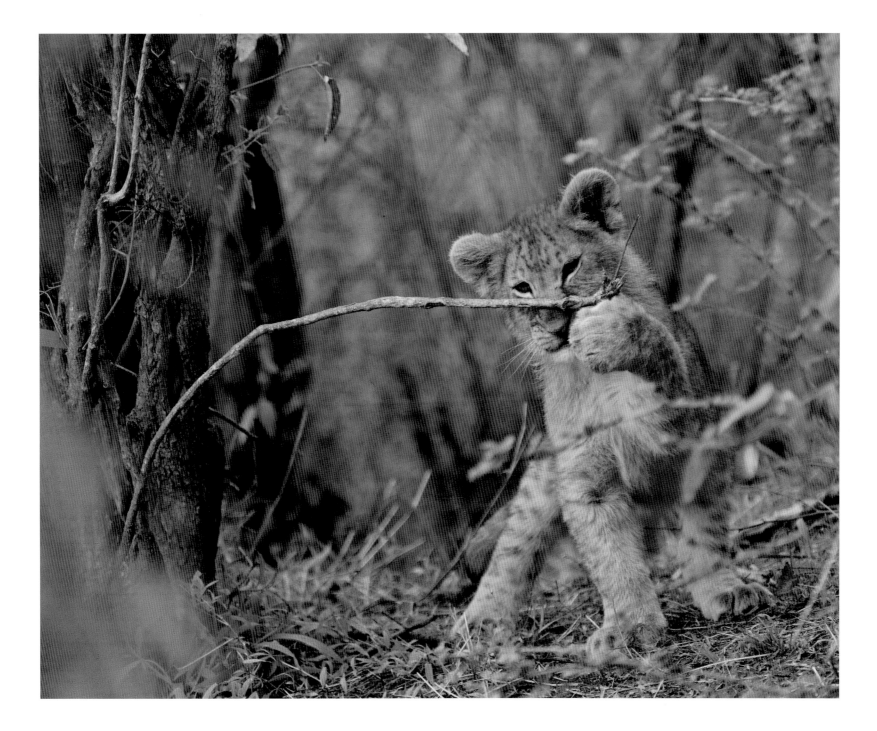

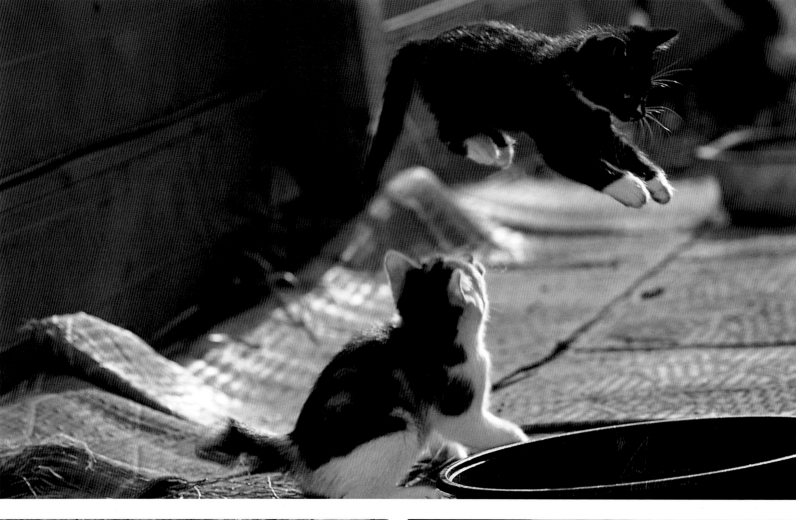

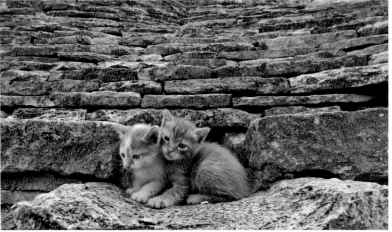

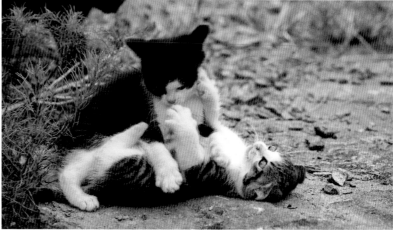

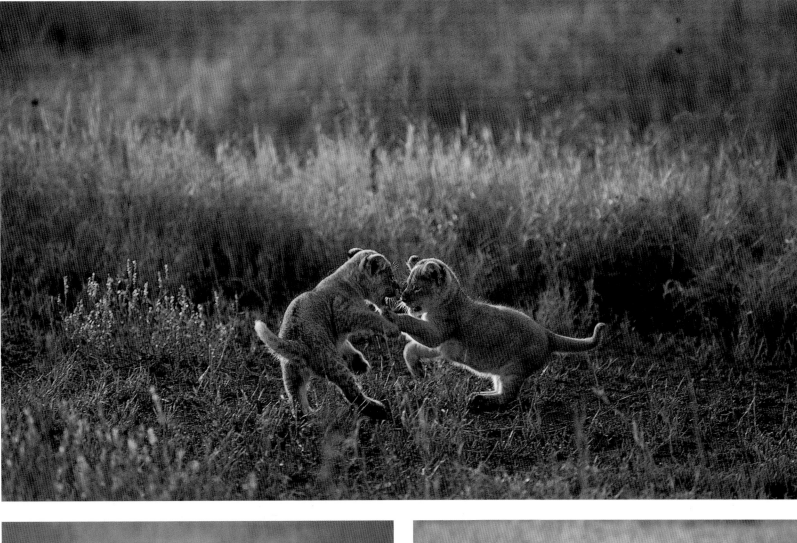

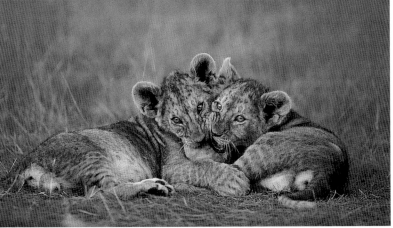

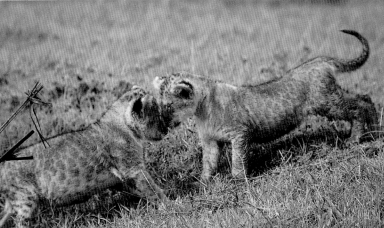

Playtime is good exercise.

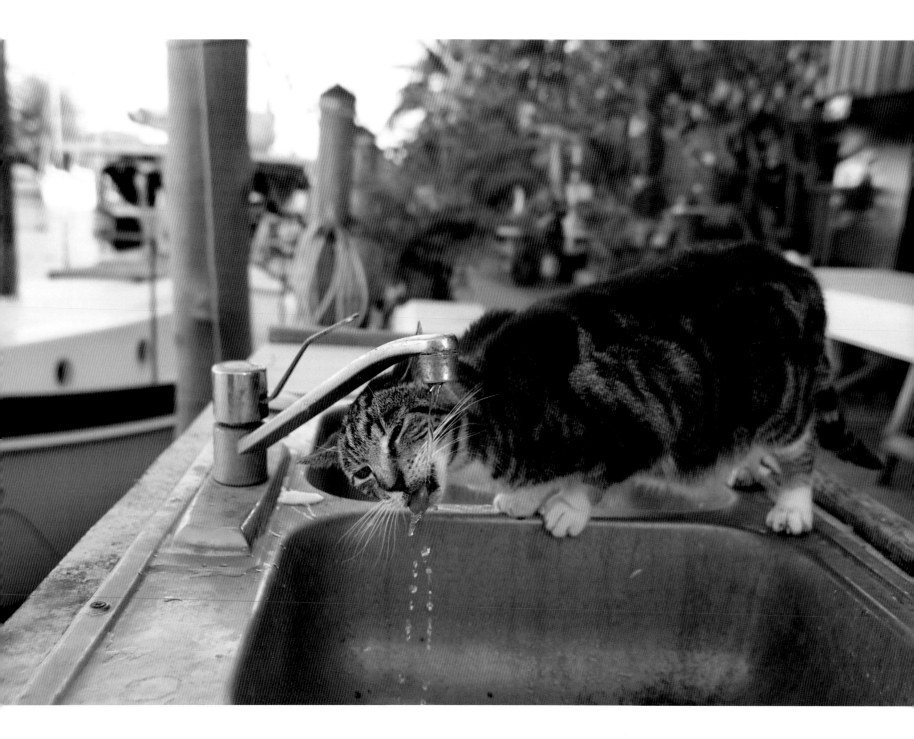

76      Watering holes come in all shape and sizes.

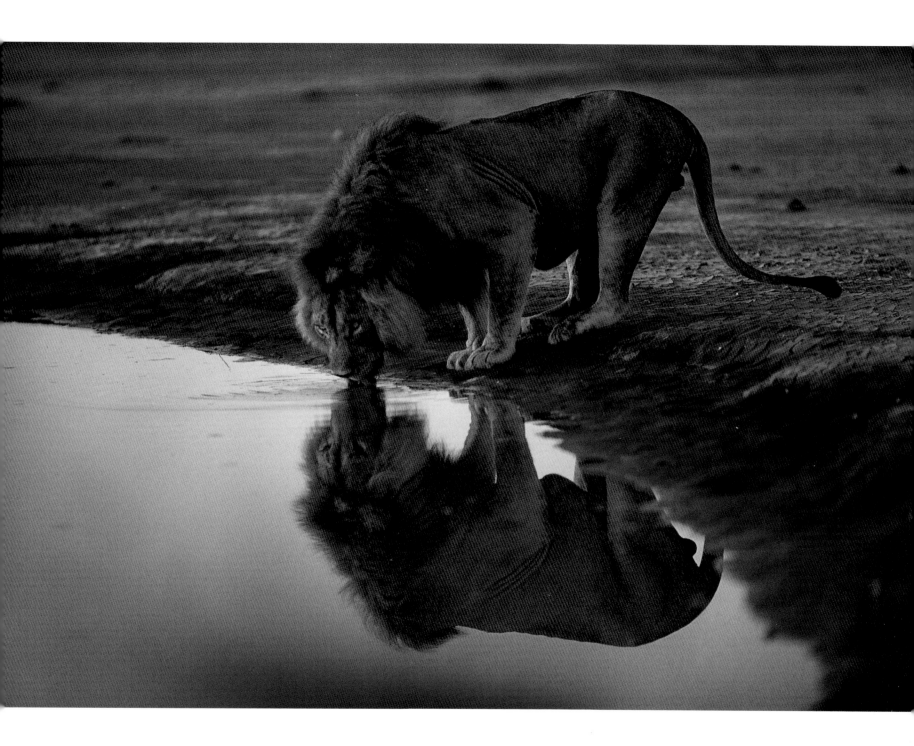

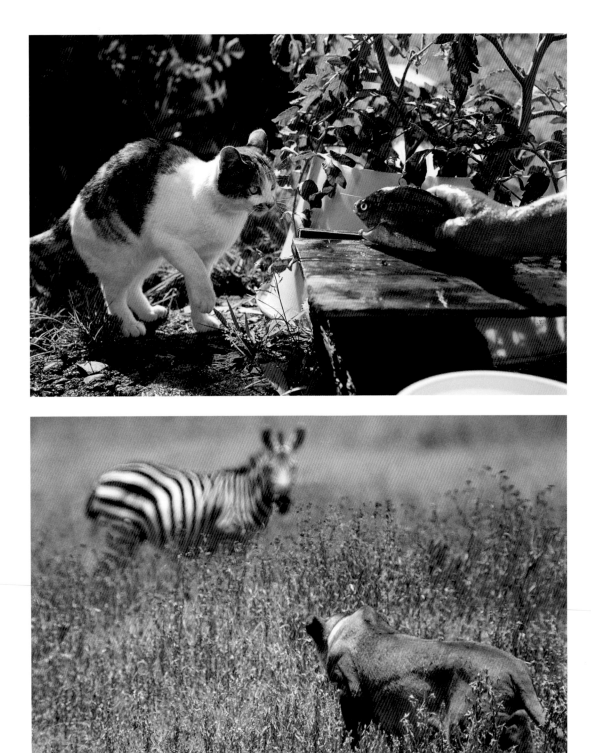

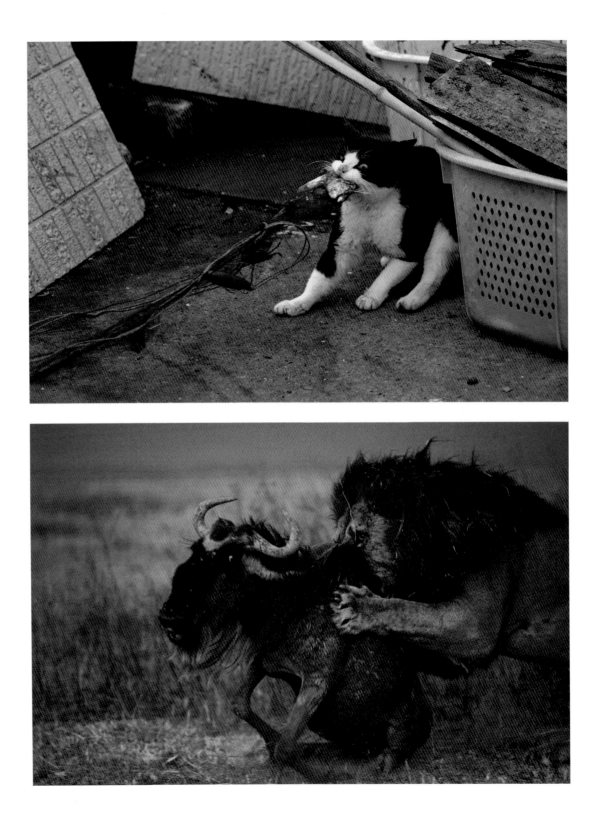

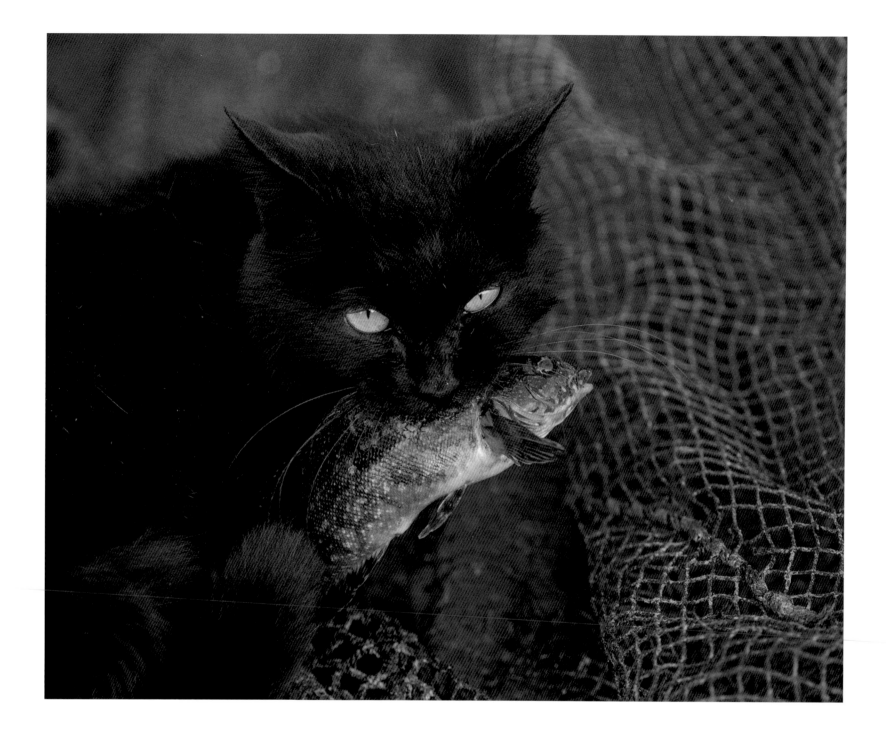

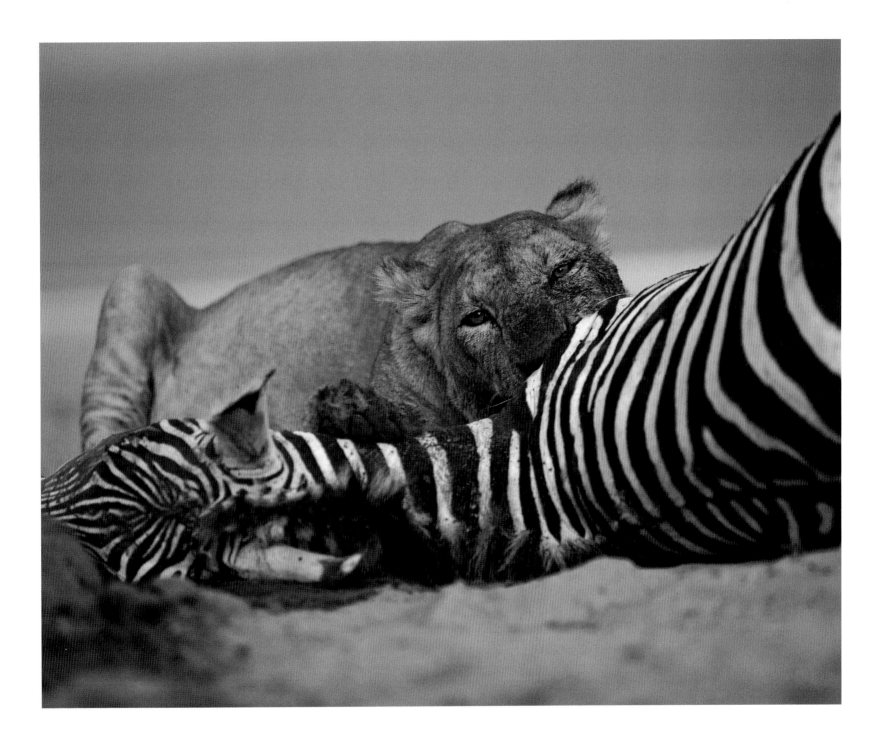

A well-earned meal.

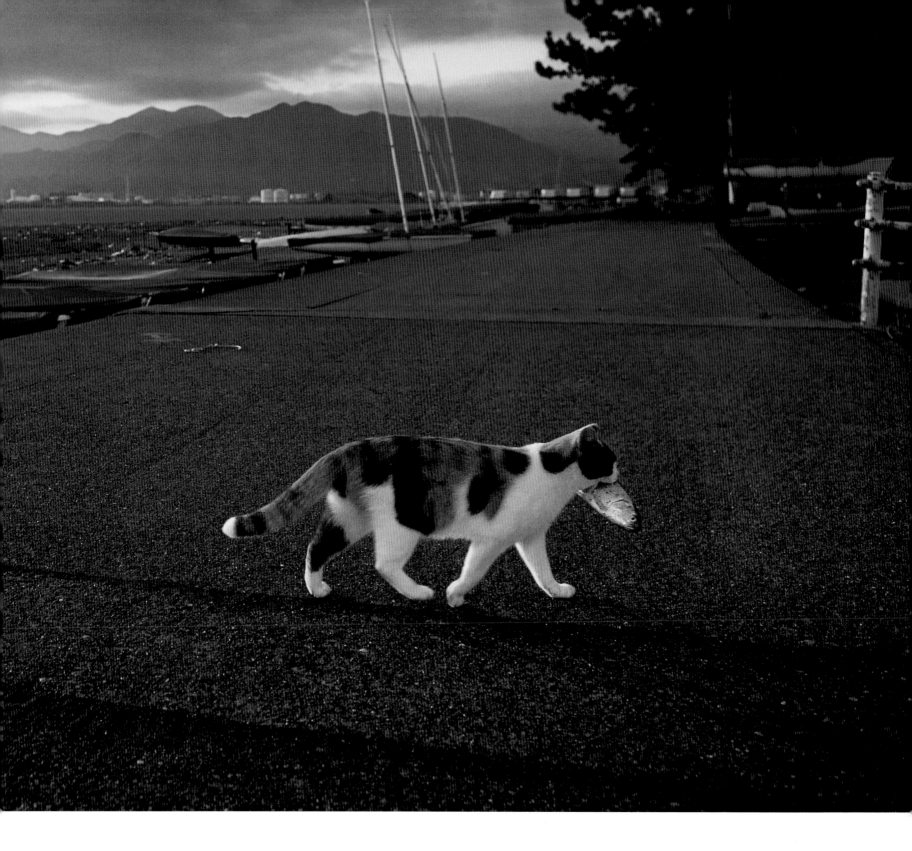

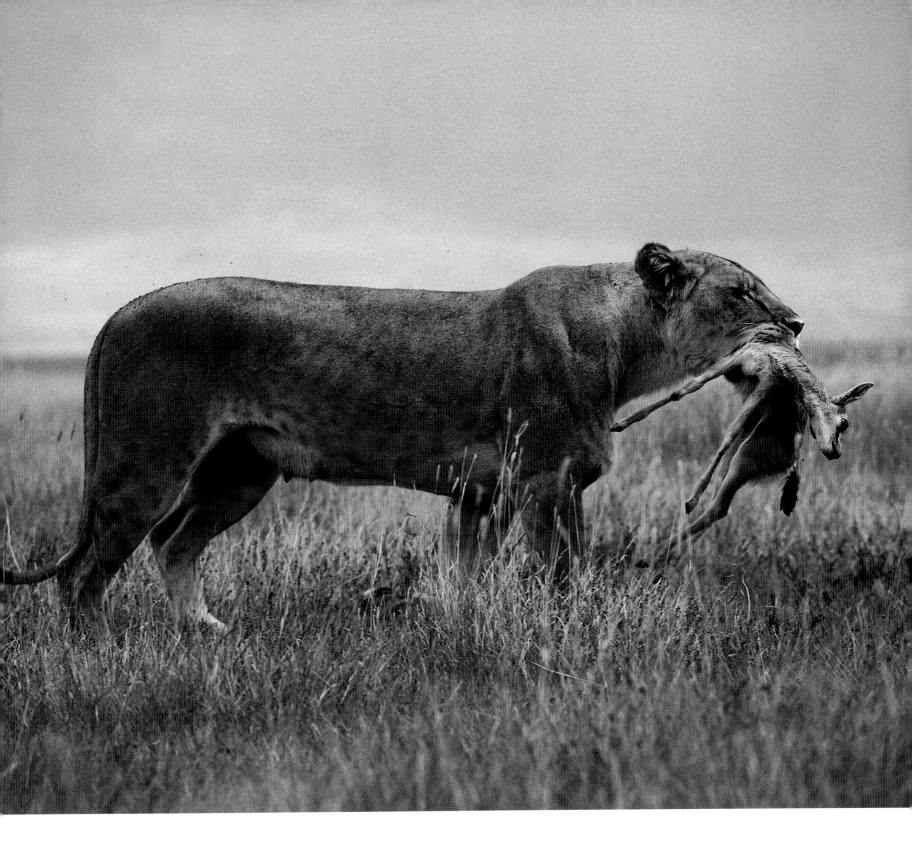

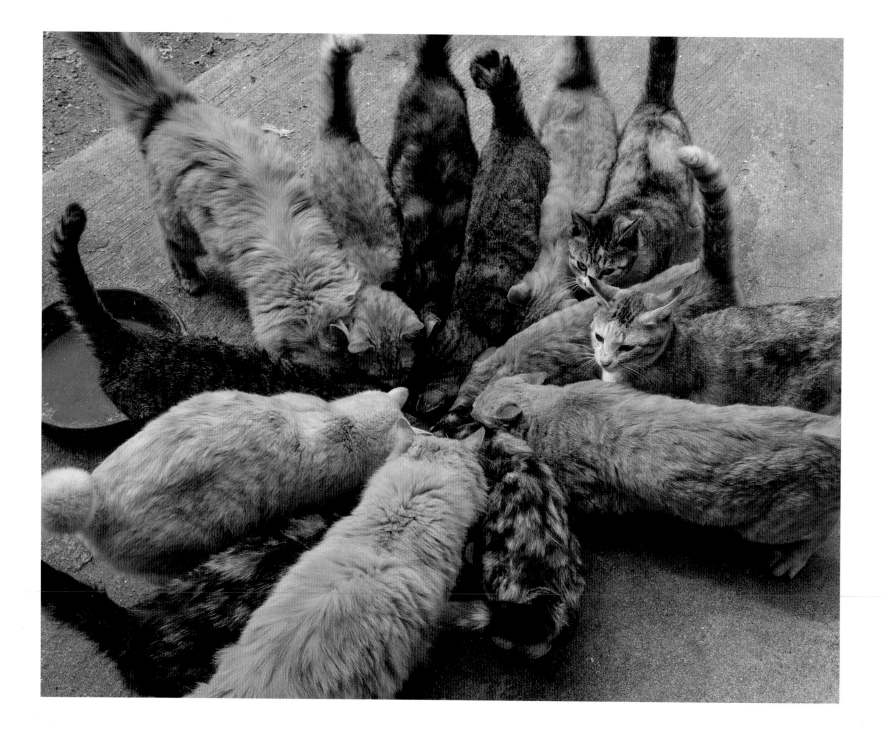

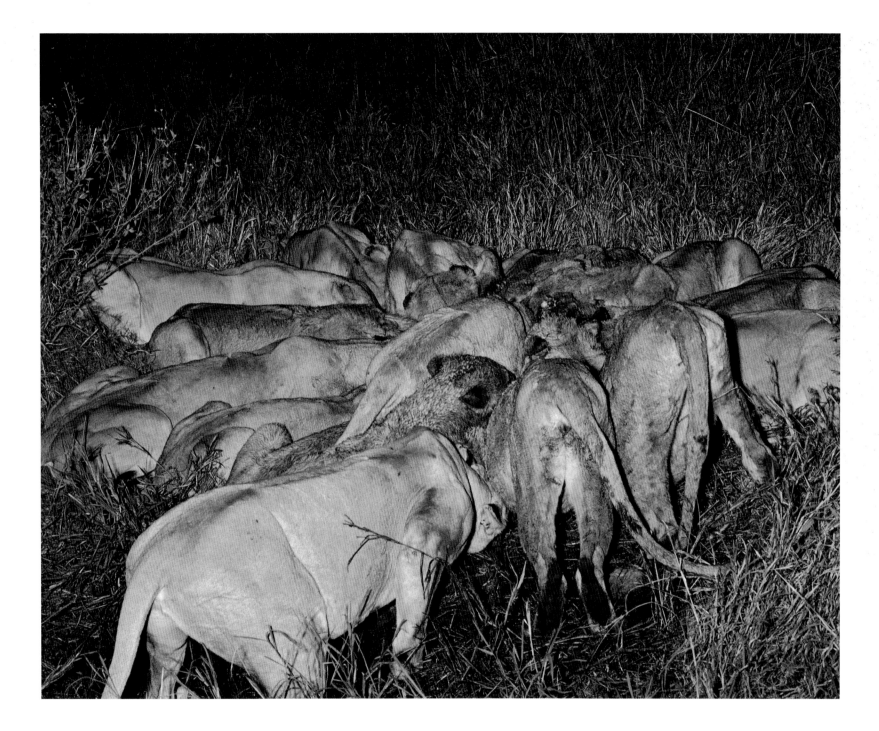

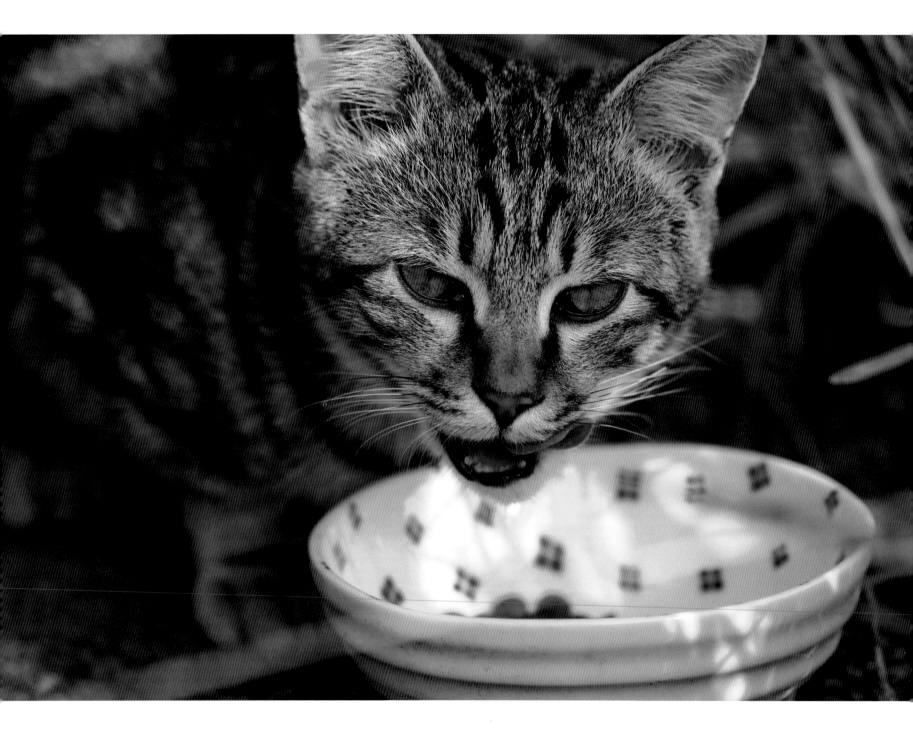

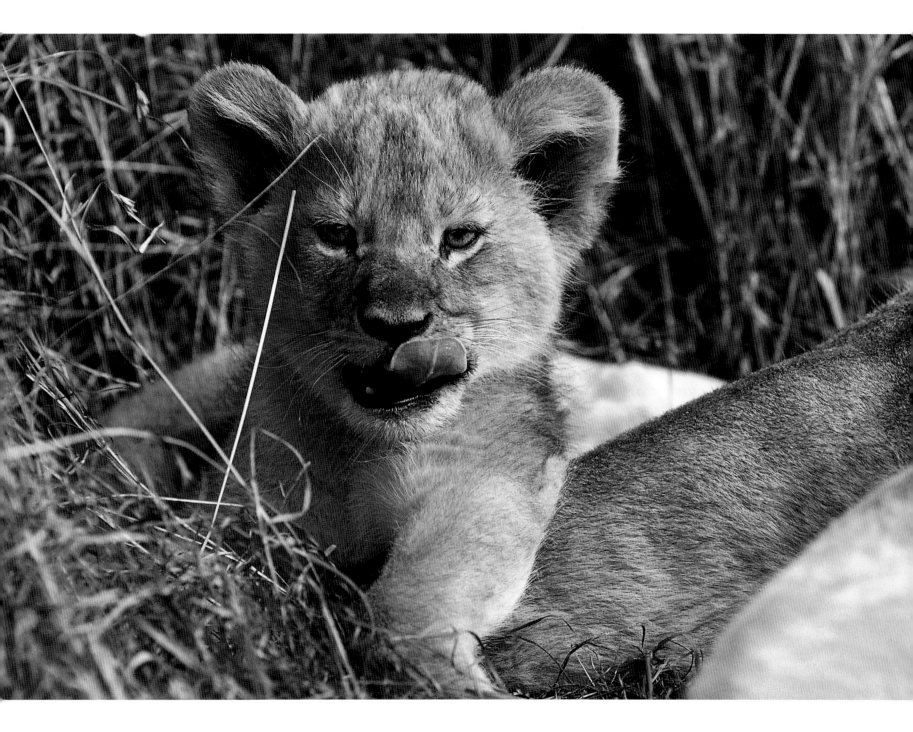

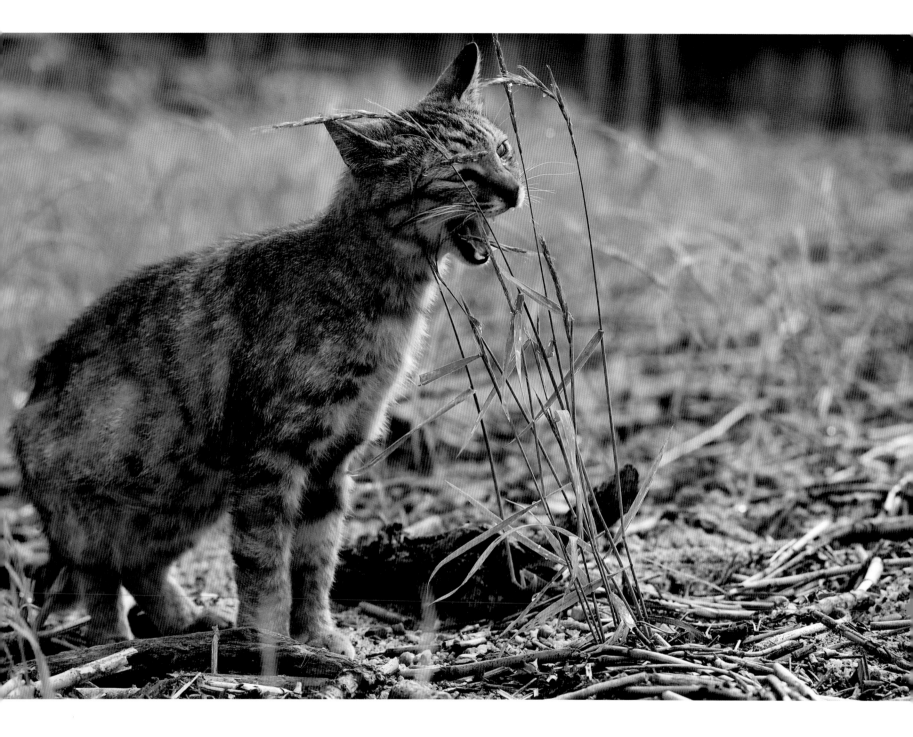

Grasses help with digestion.

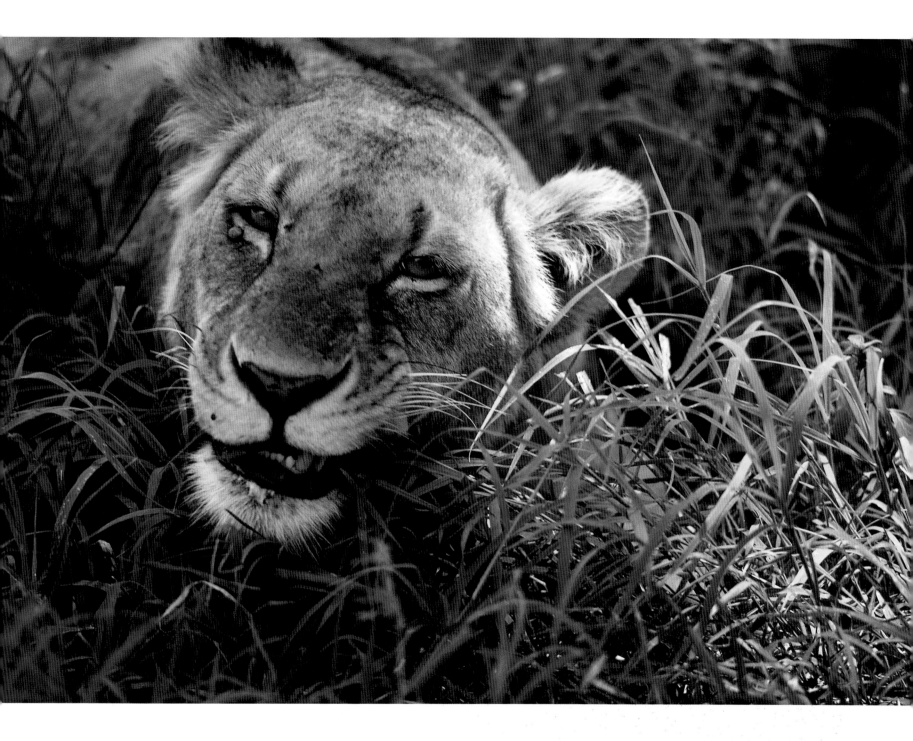

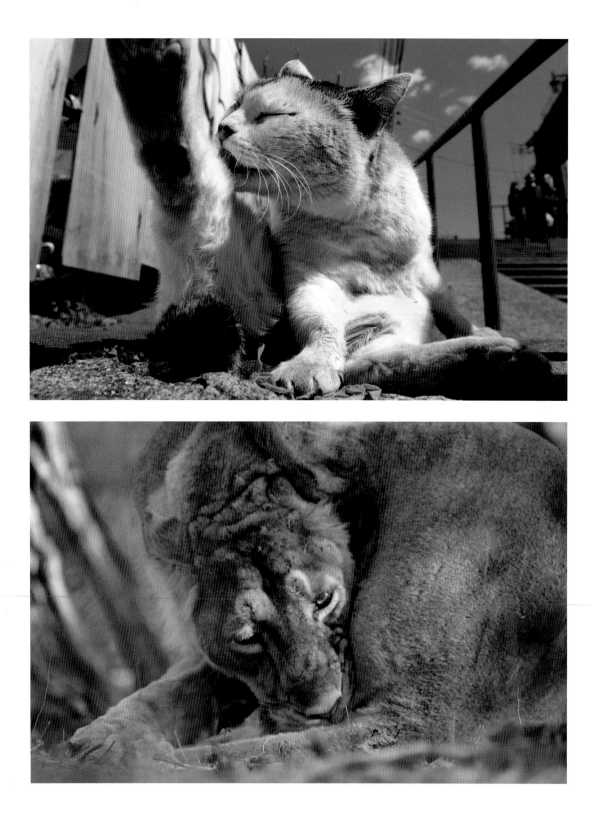

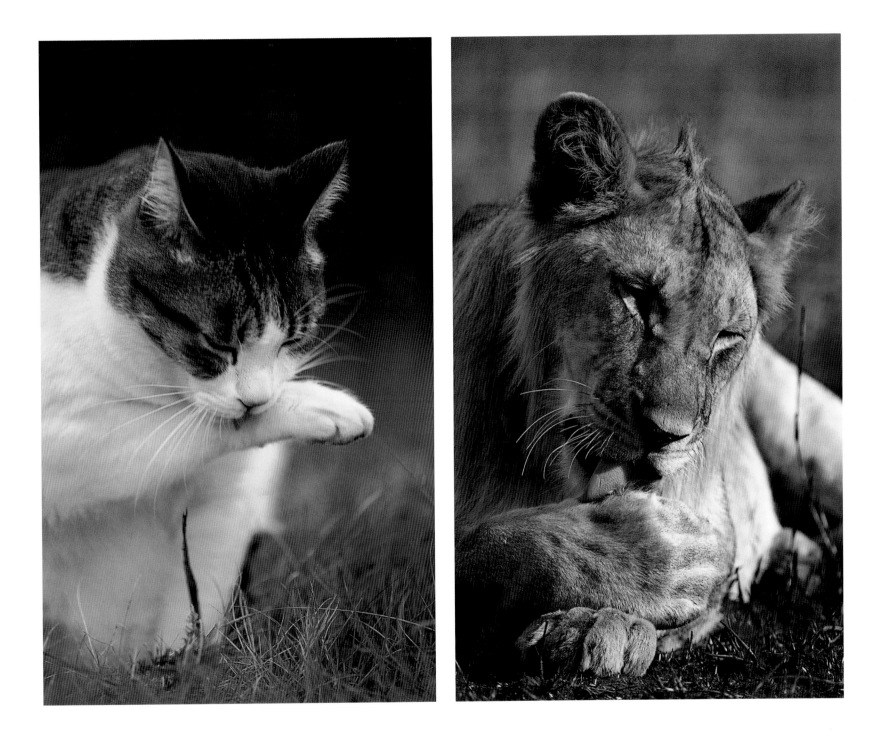

After a meal is a perfect time for grooming.

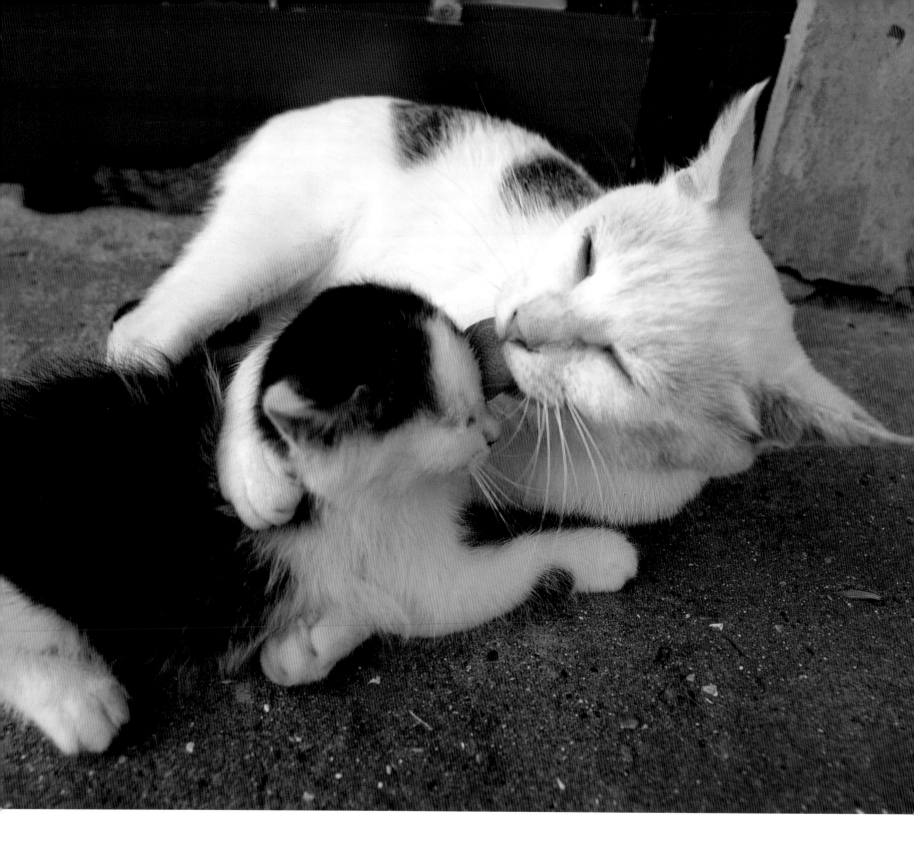

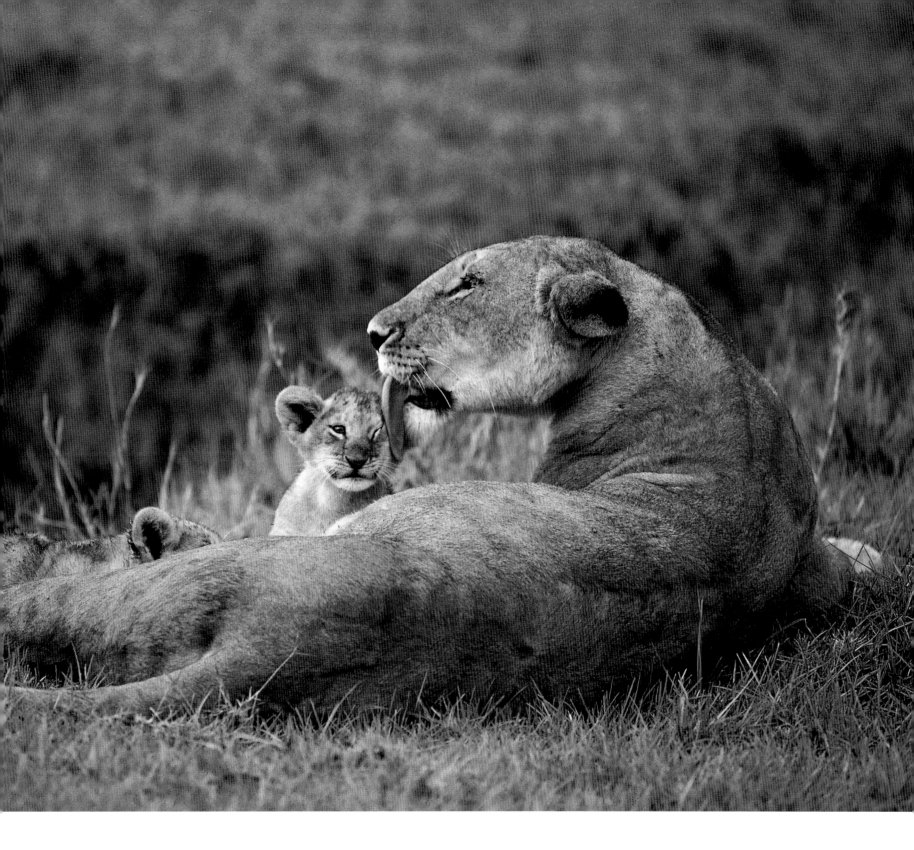

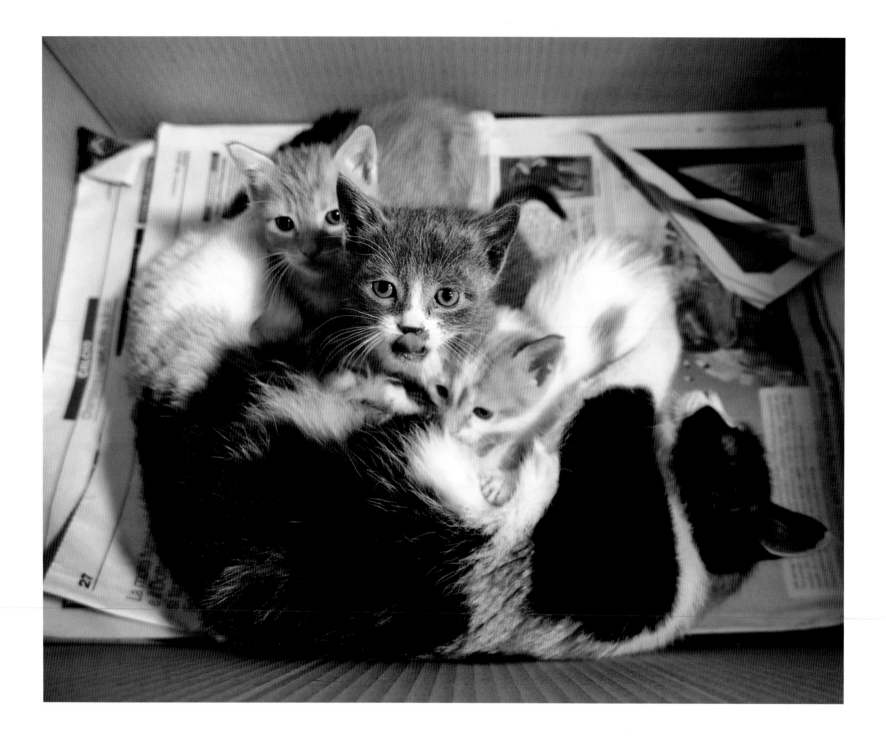

The mother chooses a quiet spot.

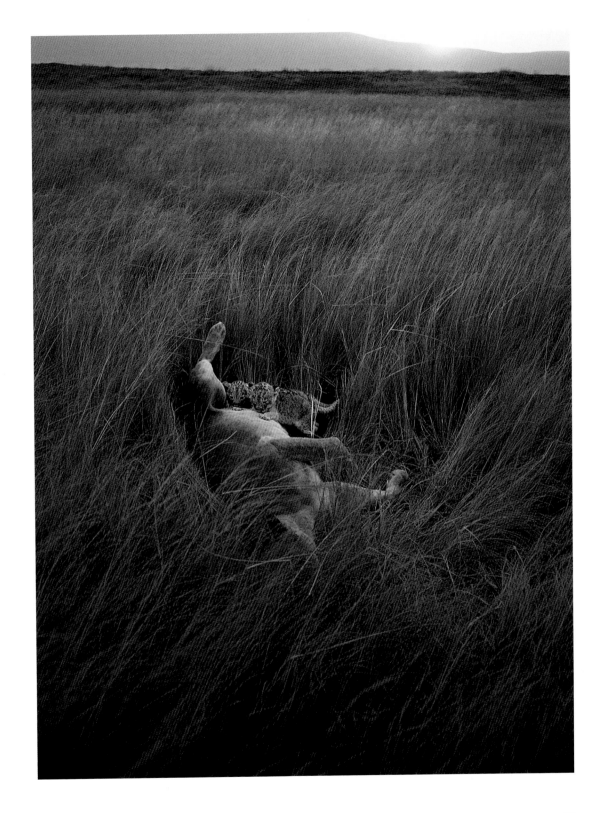

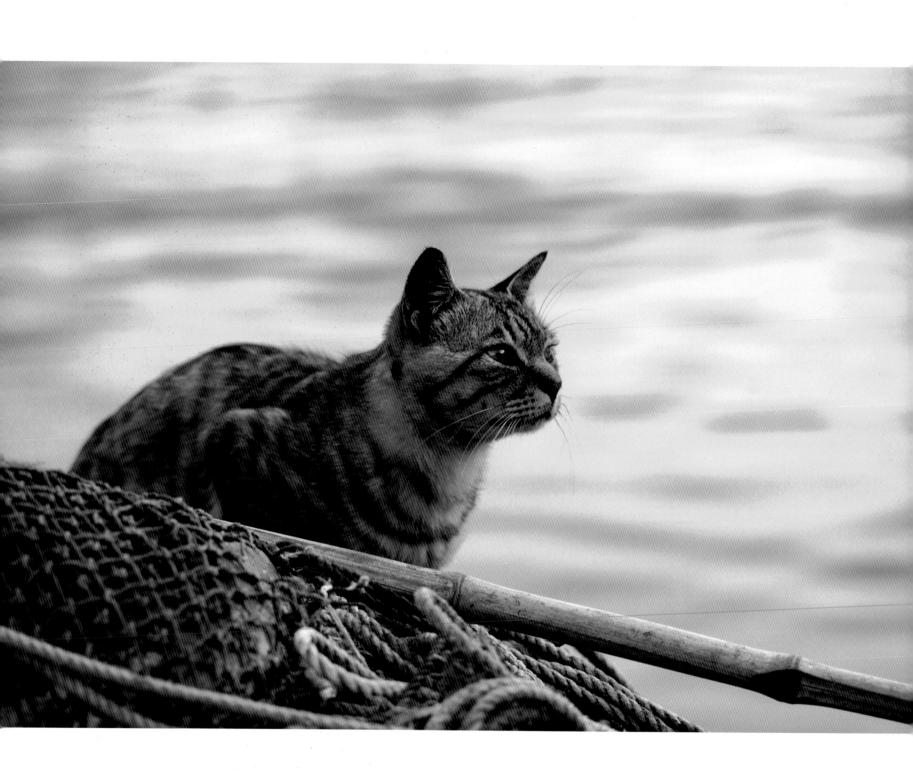

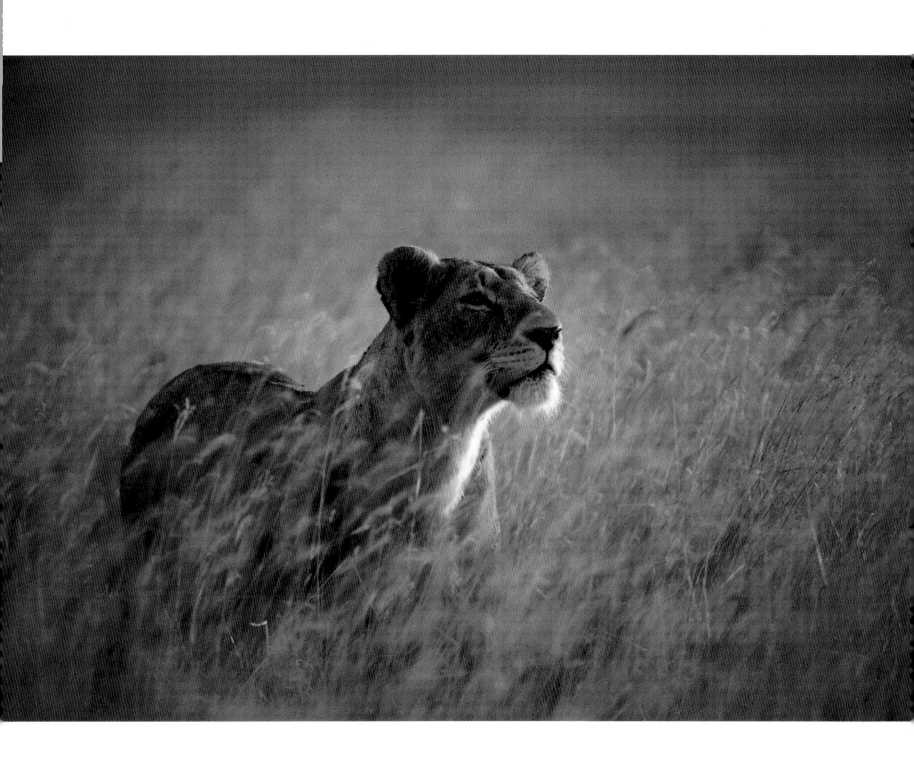

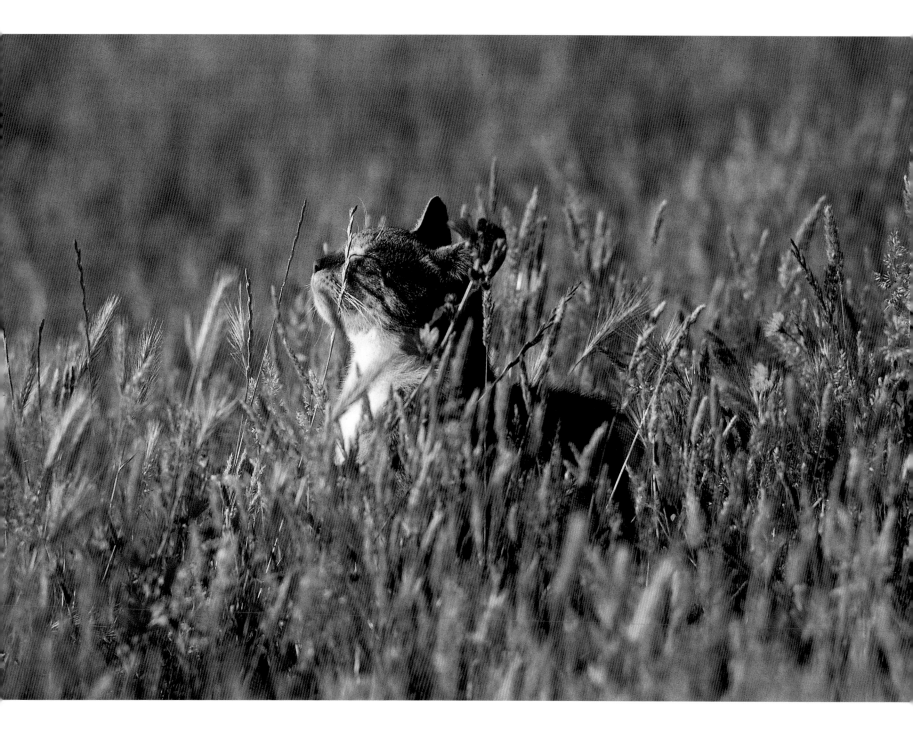

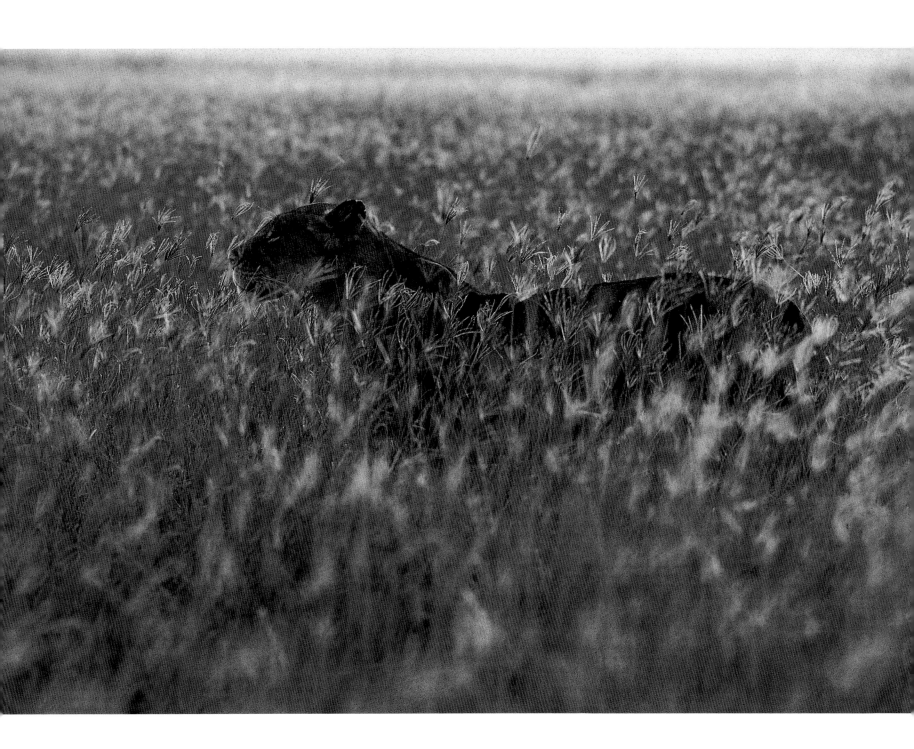

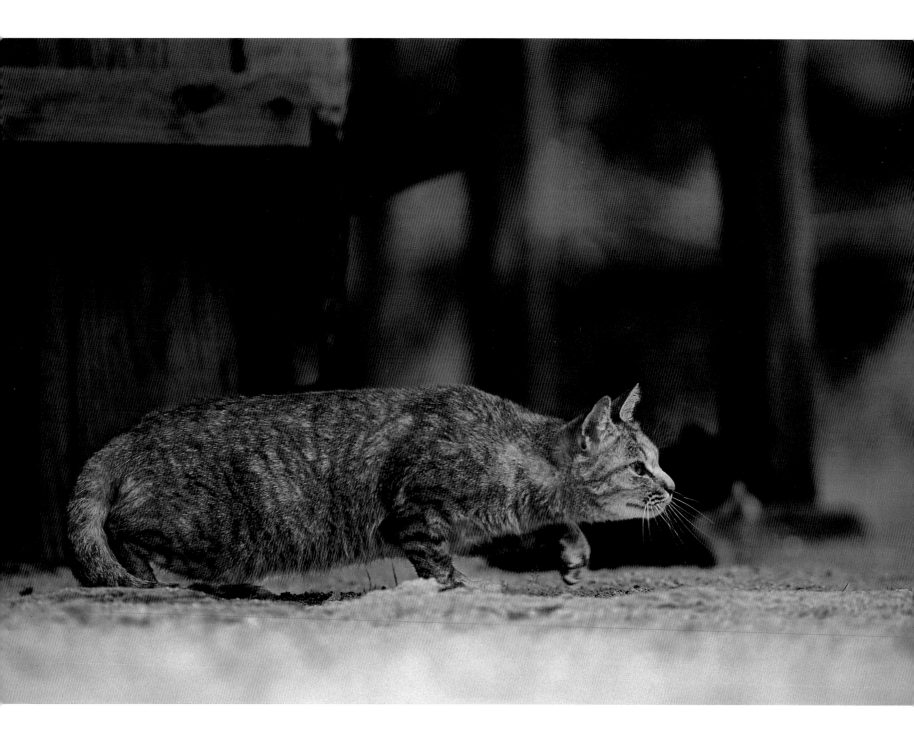

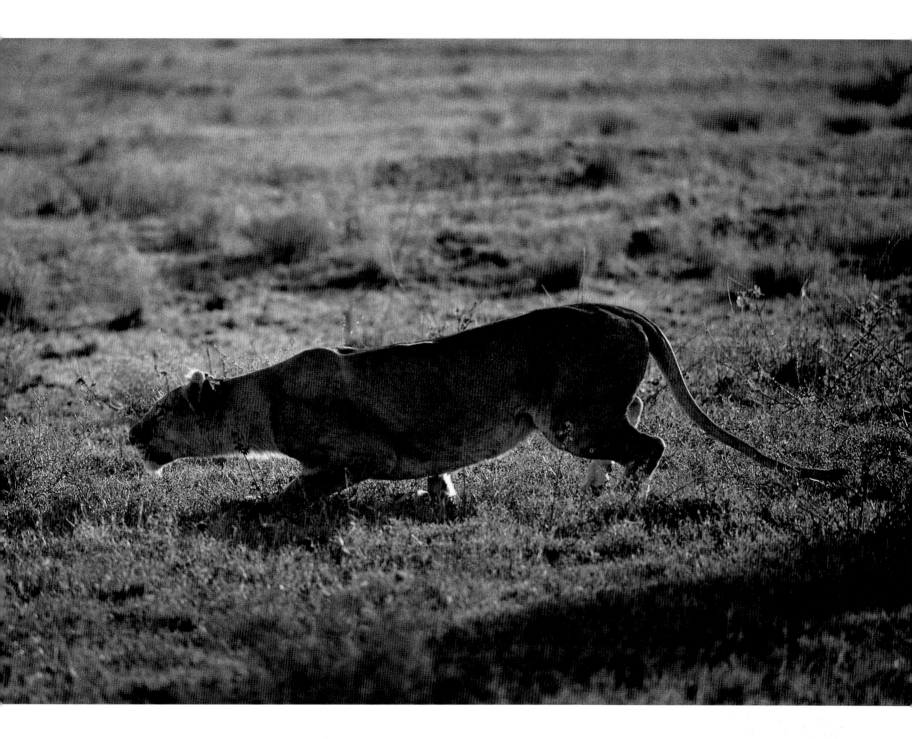

Hunting downwind increases the chance of success.

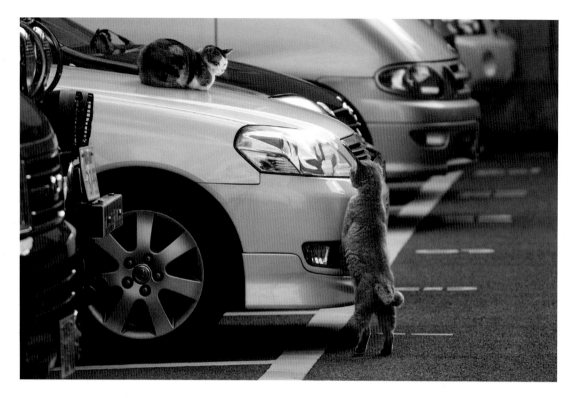

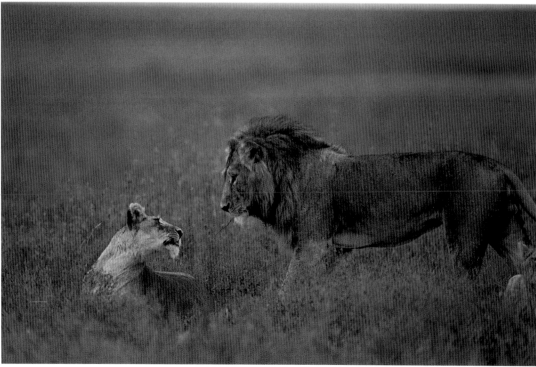

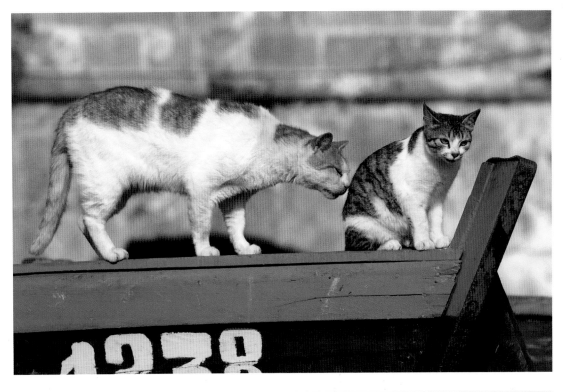

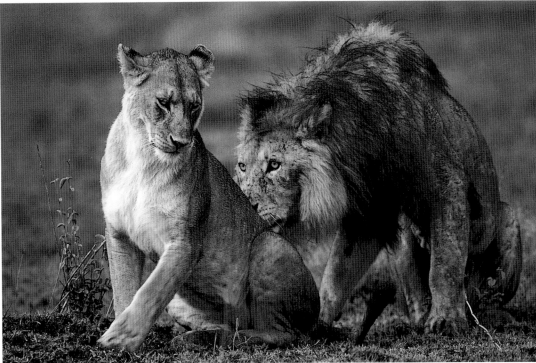

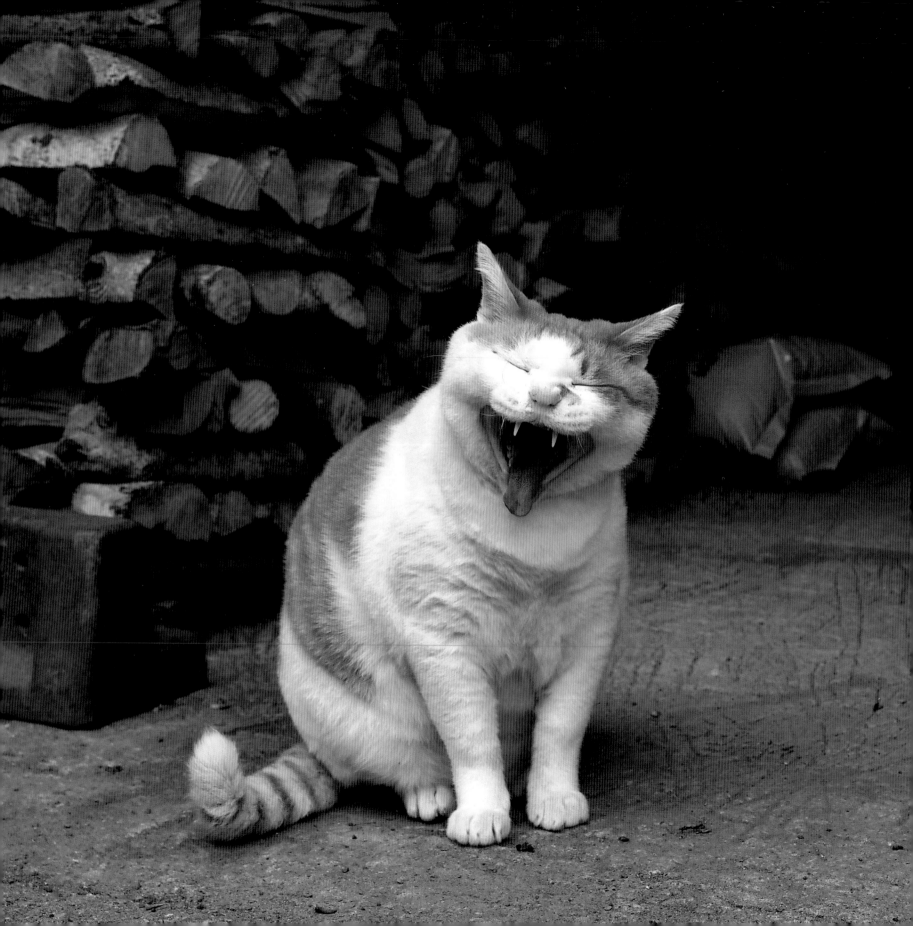

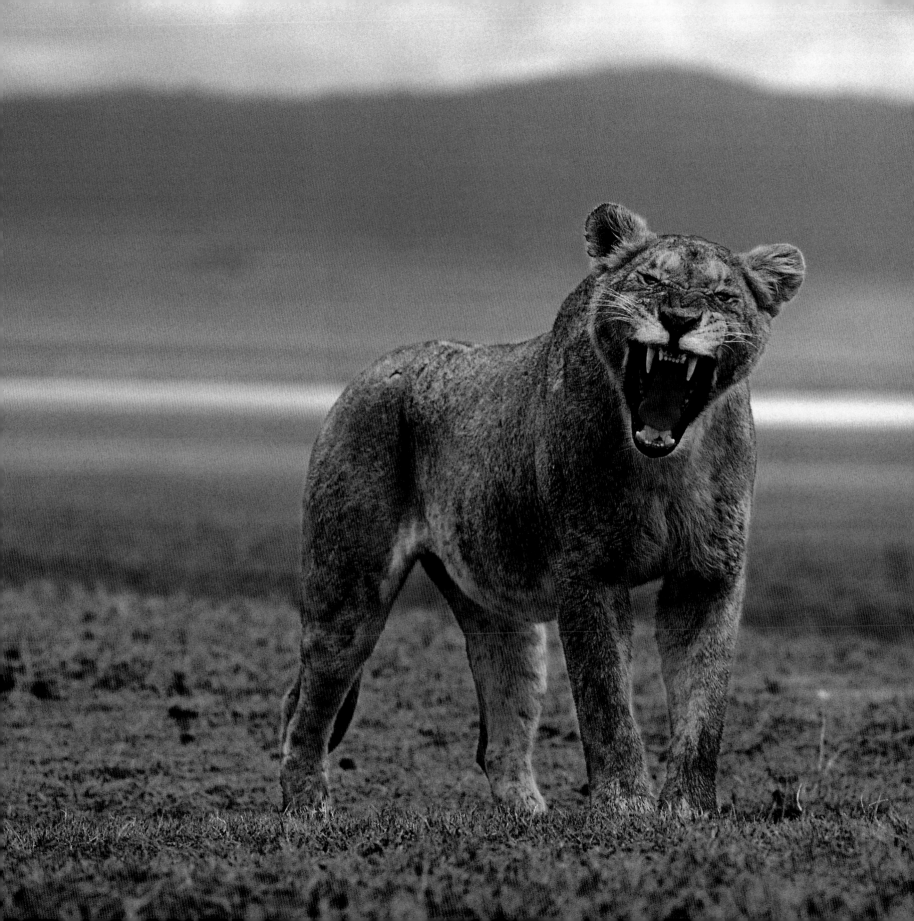

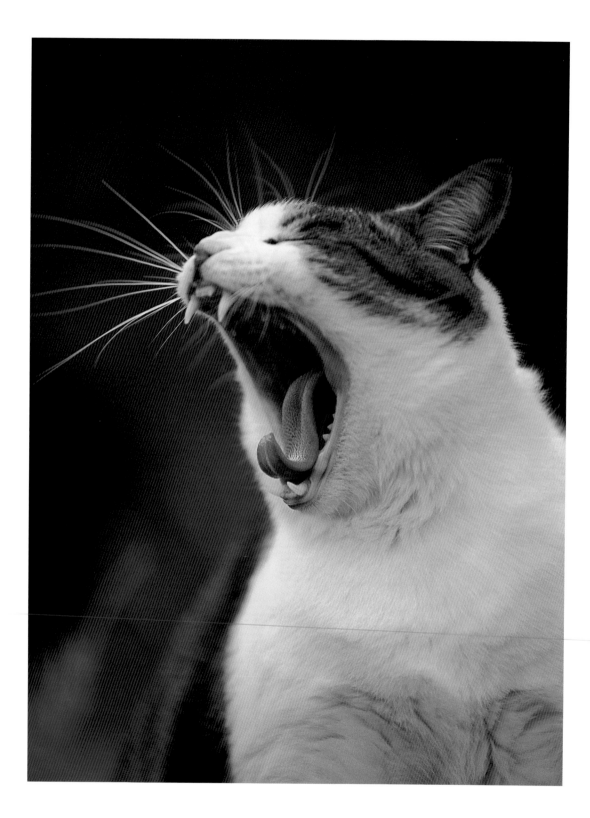

Yawning helps exercise and stretch the muscles around the mouth.

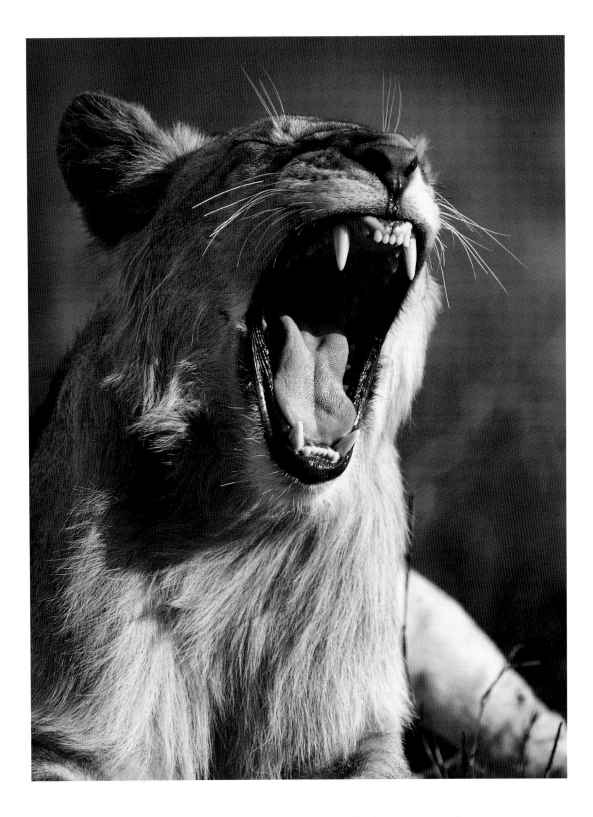

It's also a sign to take a rest.

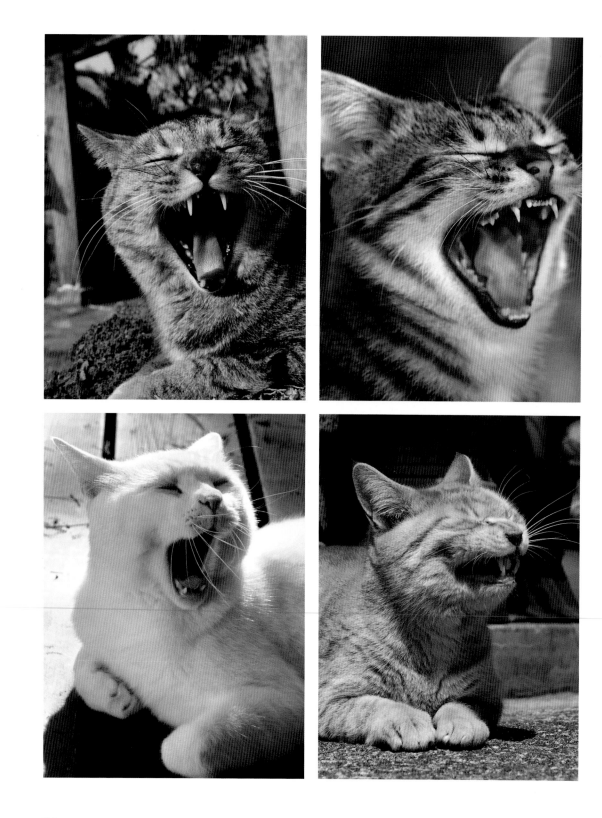

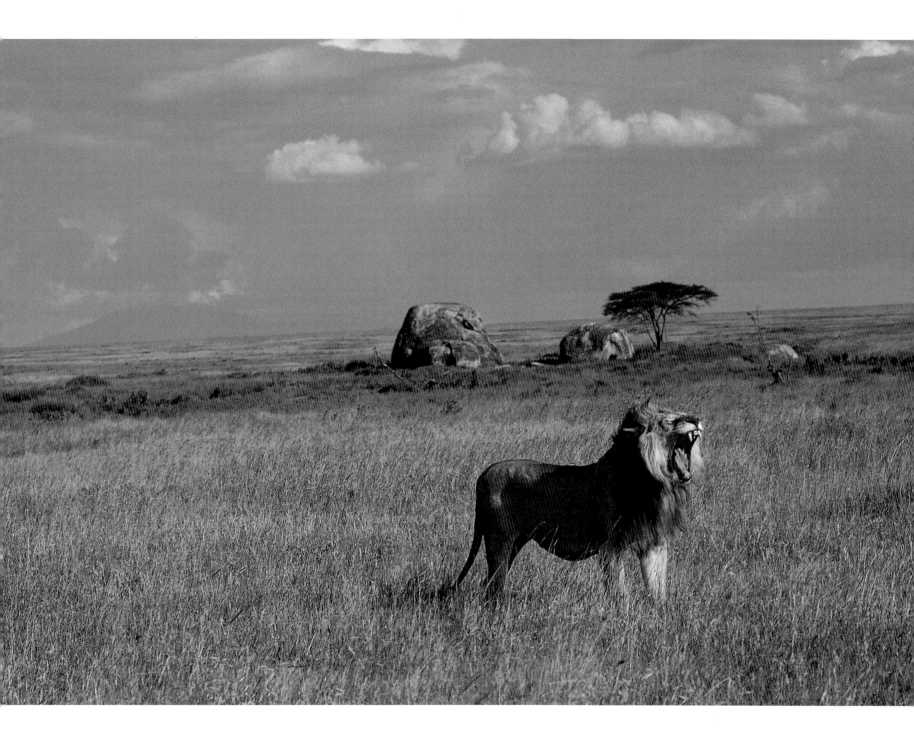

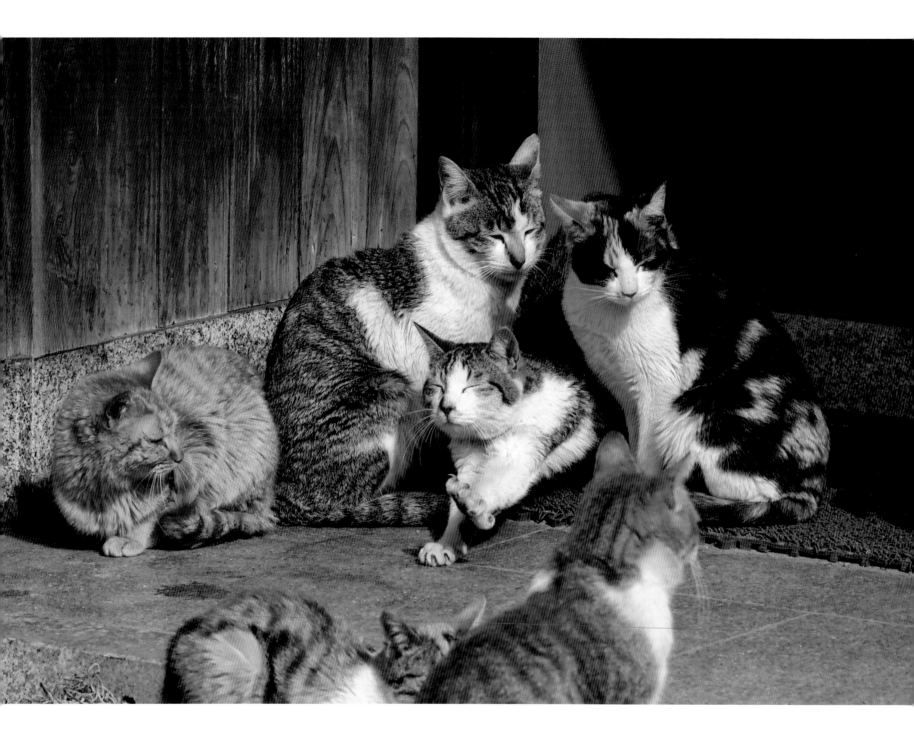

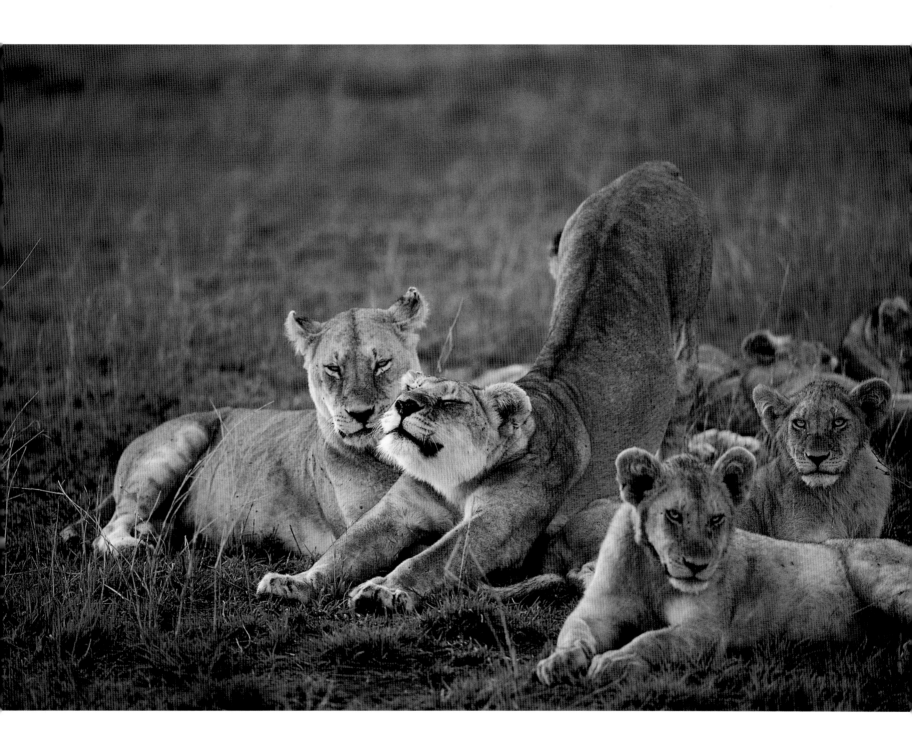

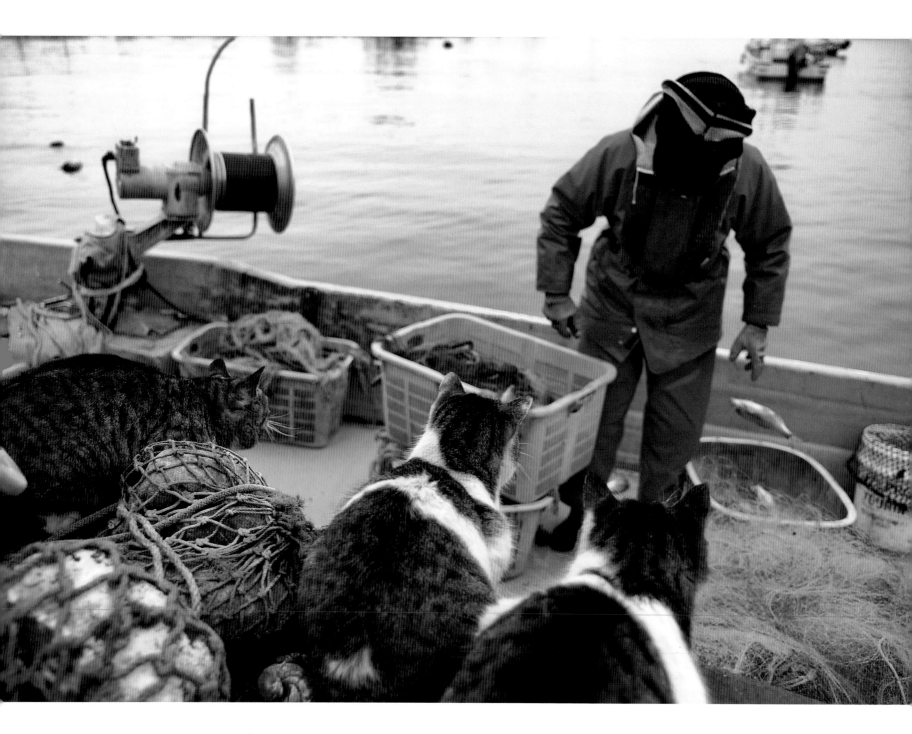

Watching intently for the next opportunity to eat.

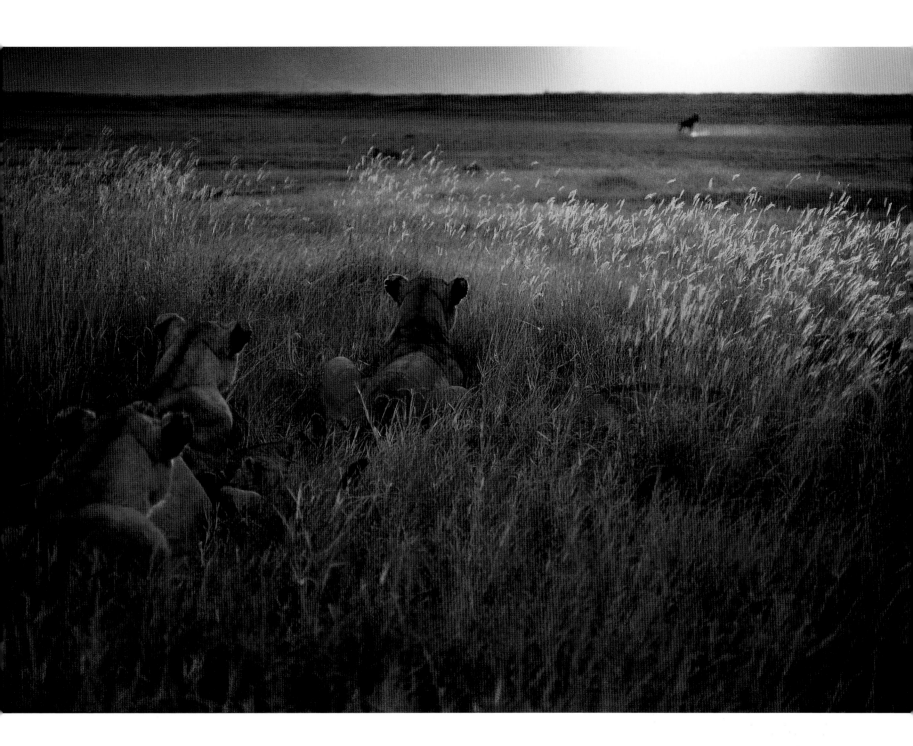

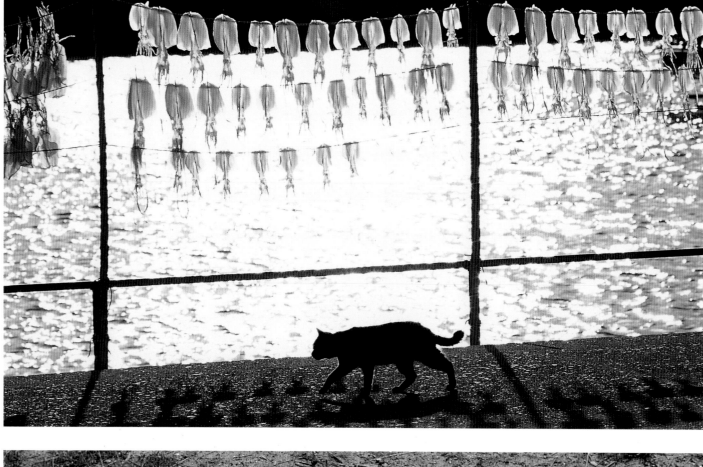

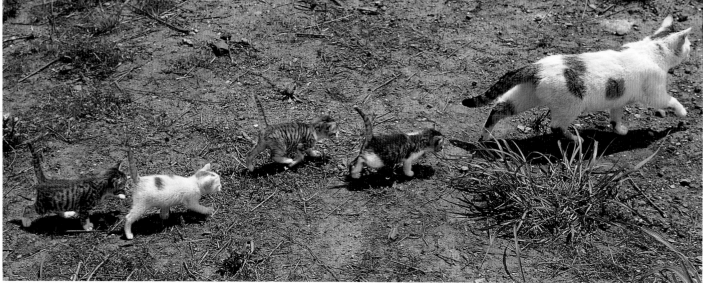

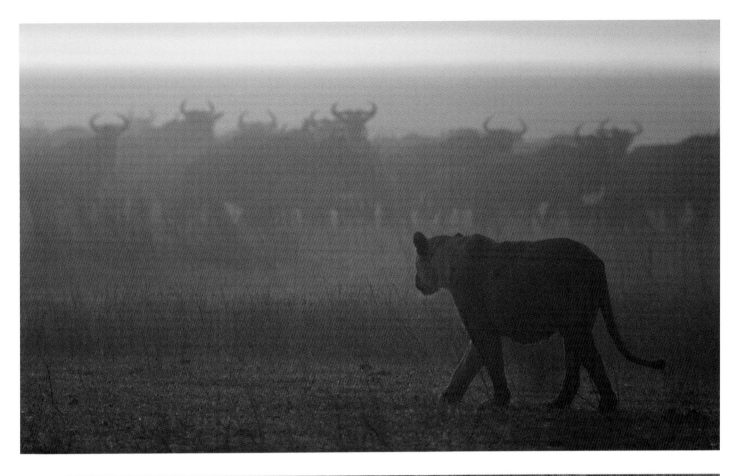

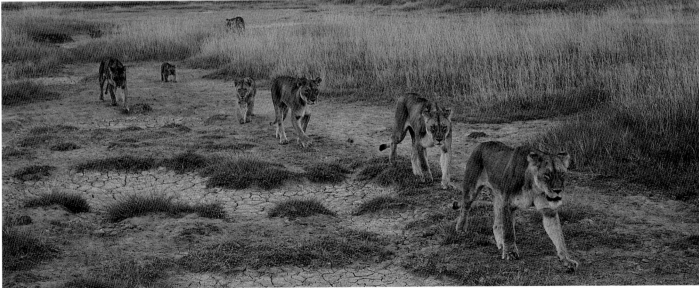

The ways of walking change according to the prey and the terrain.

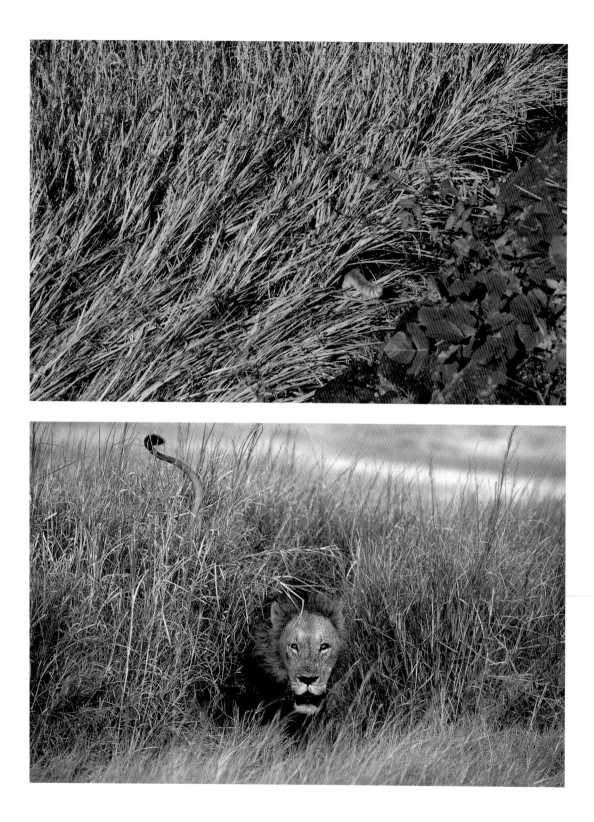

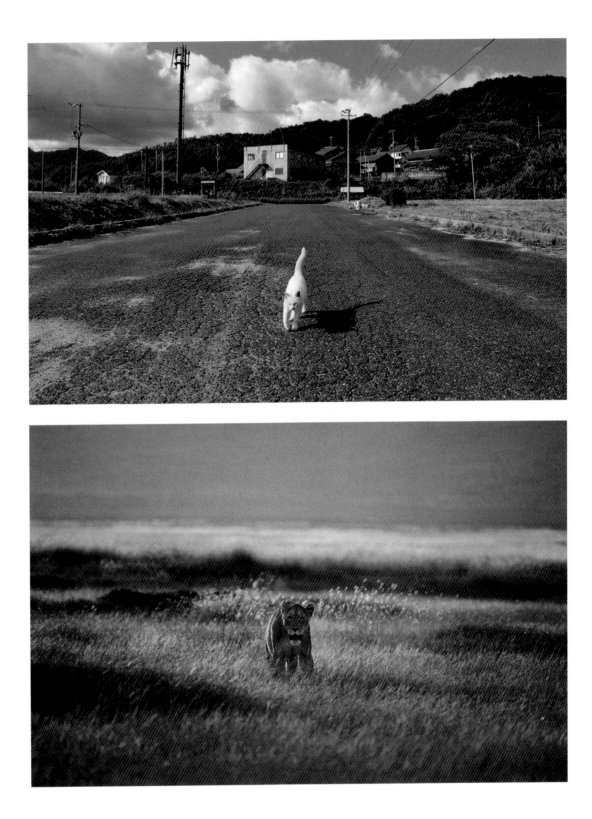

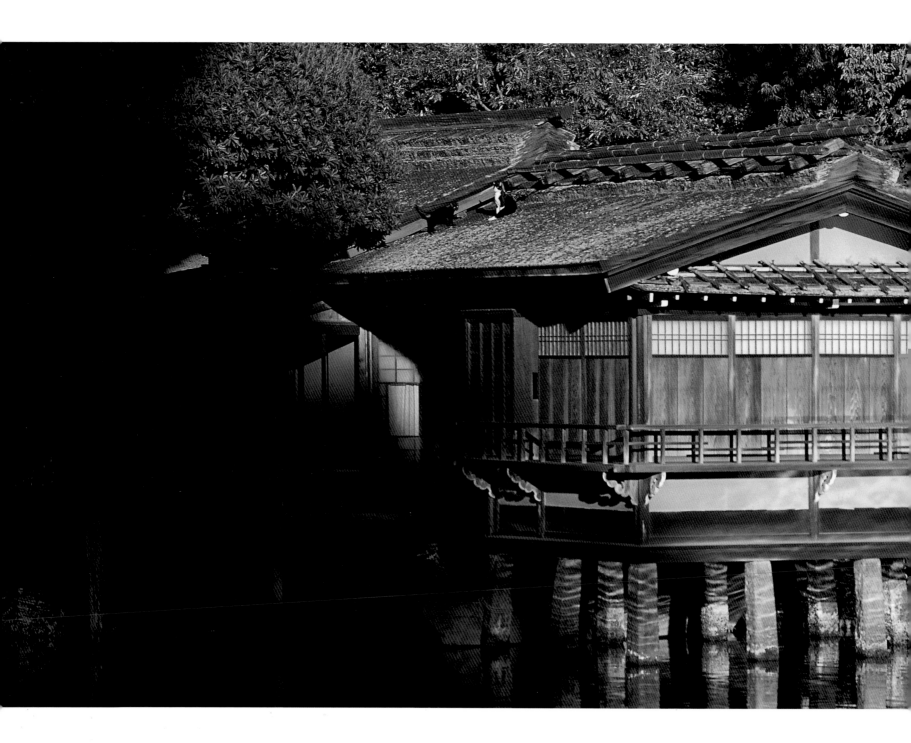

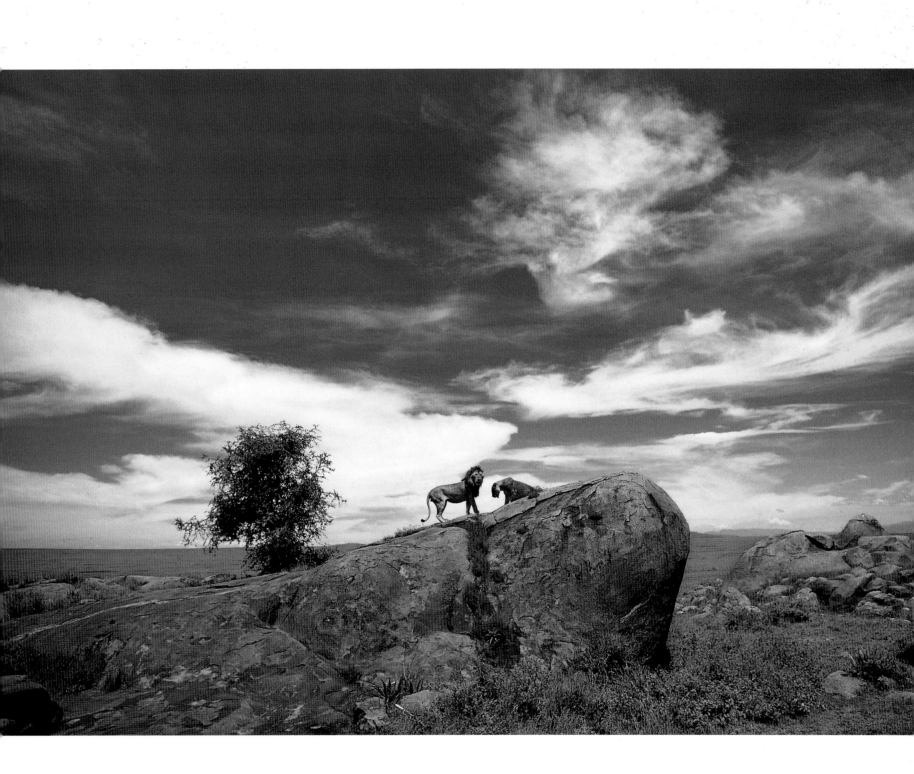

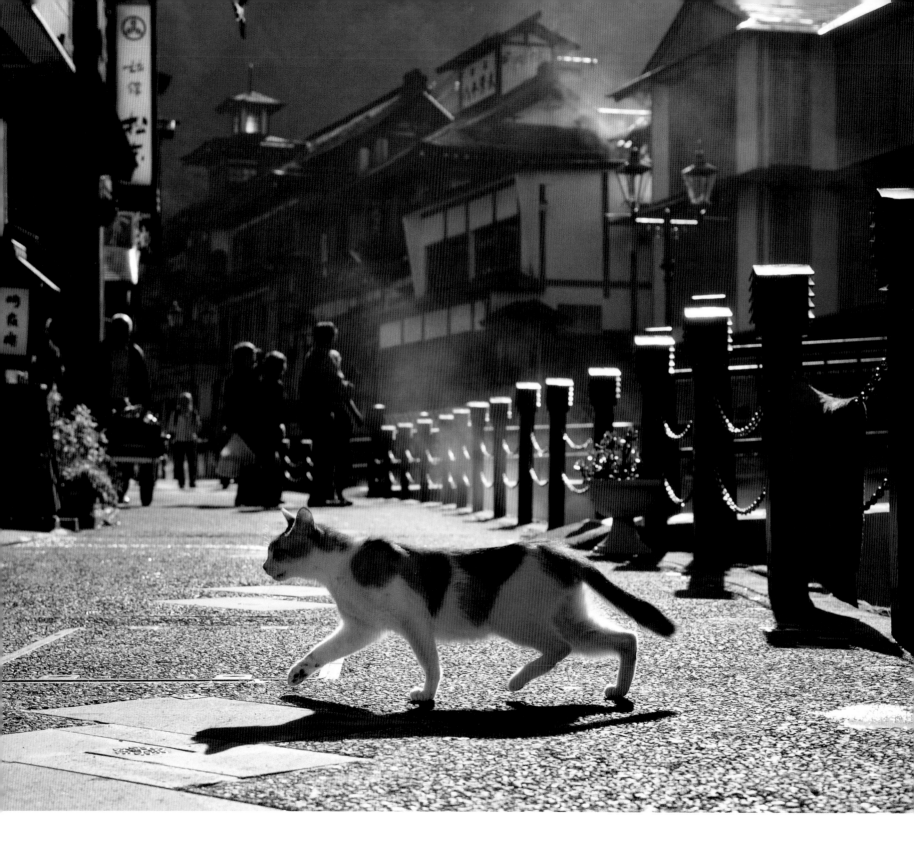

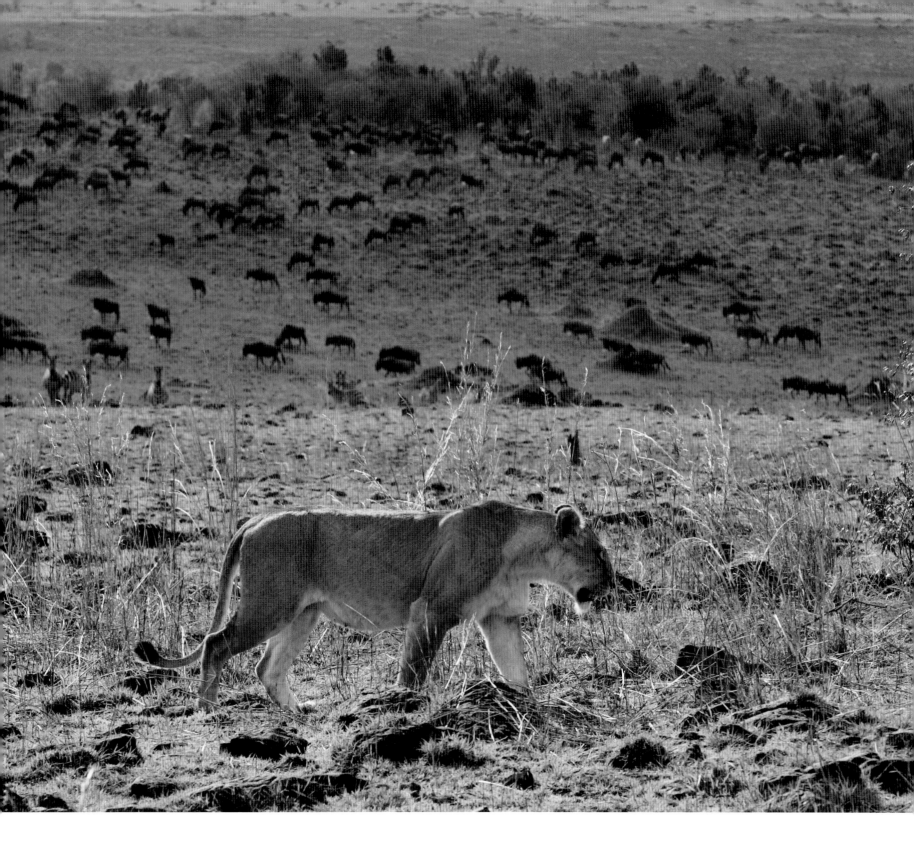

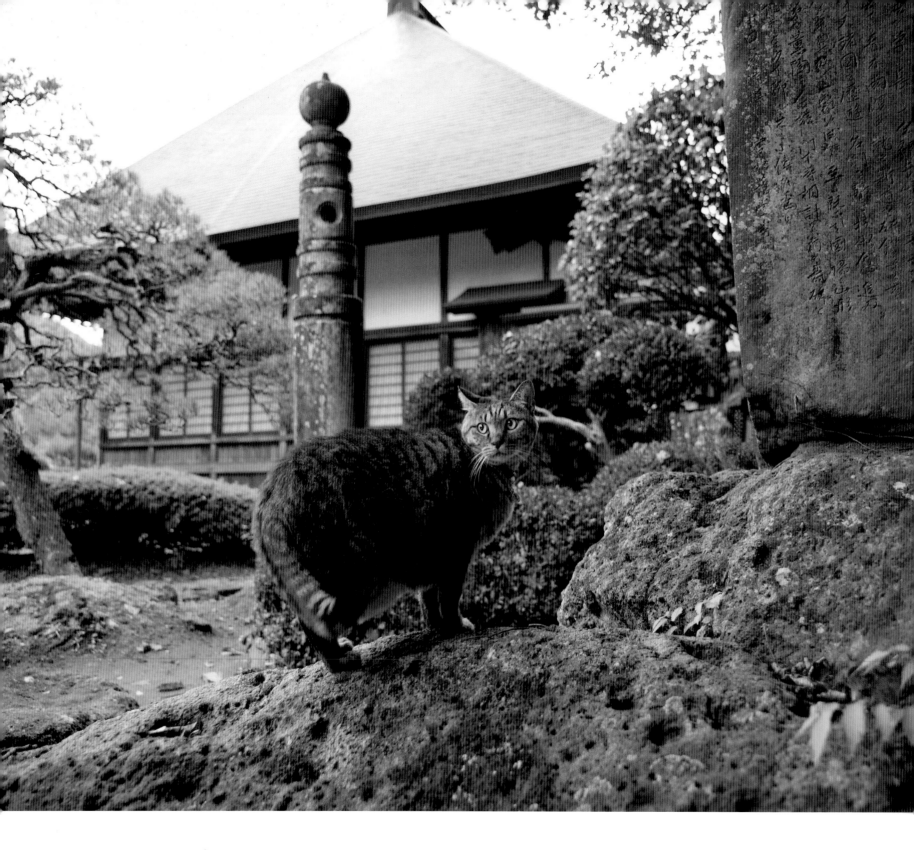

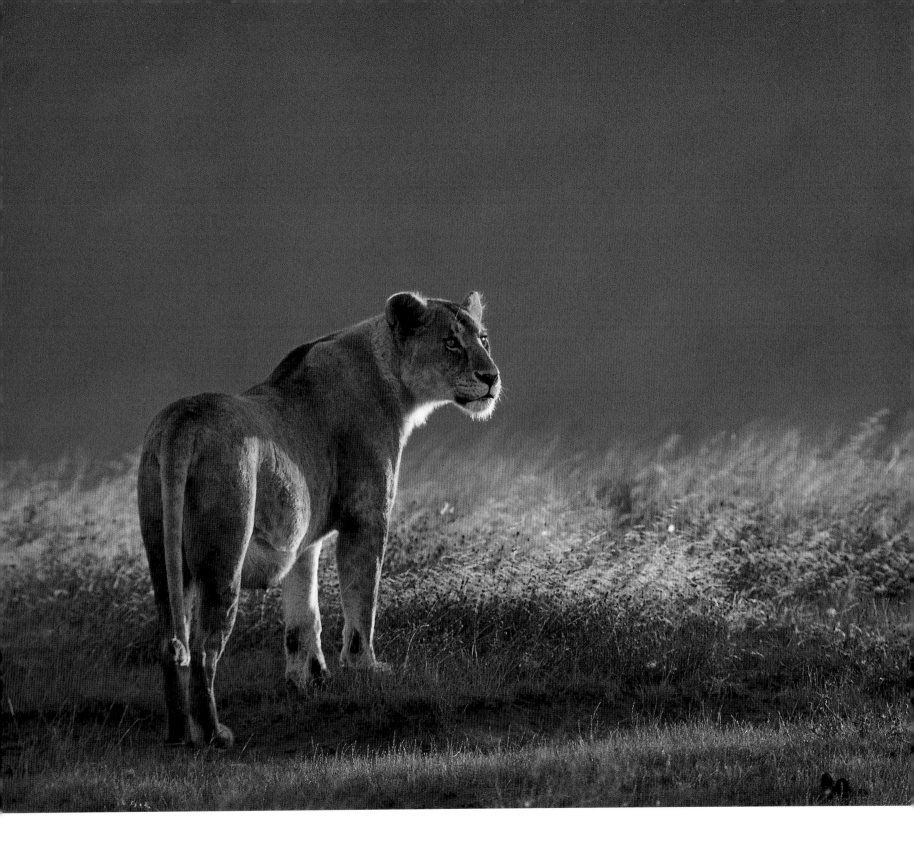

Still, but alert.

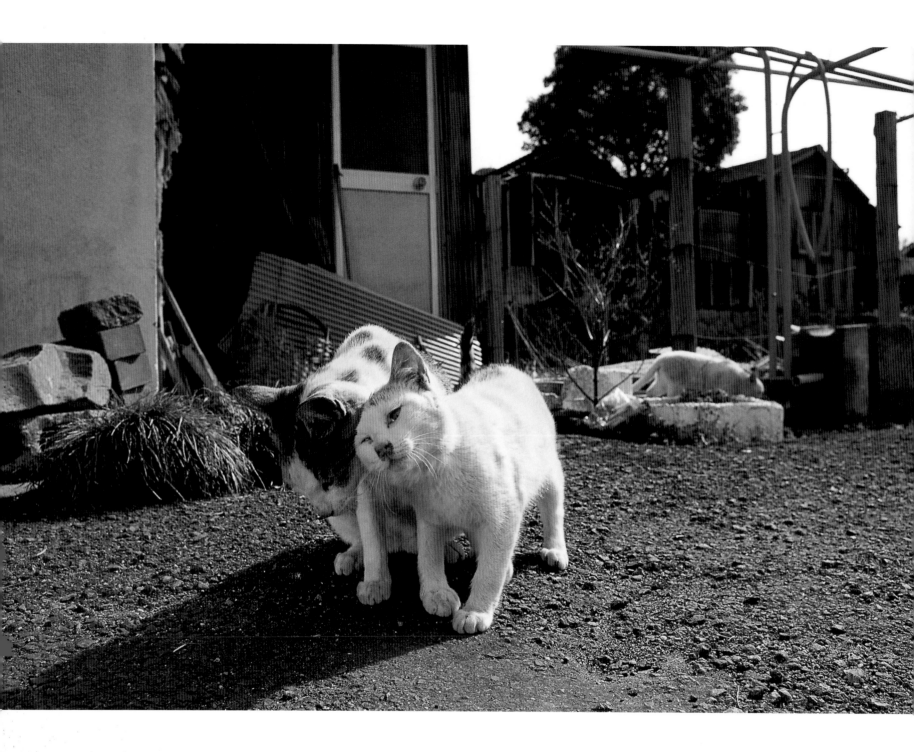

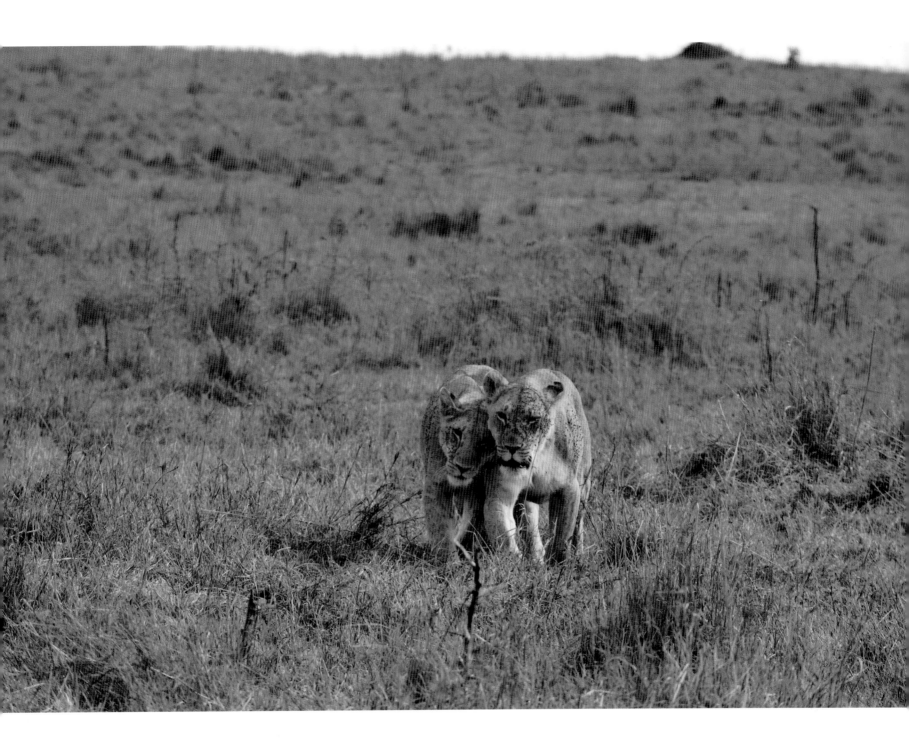

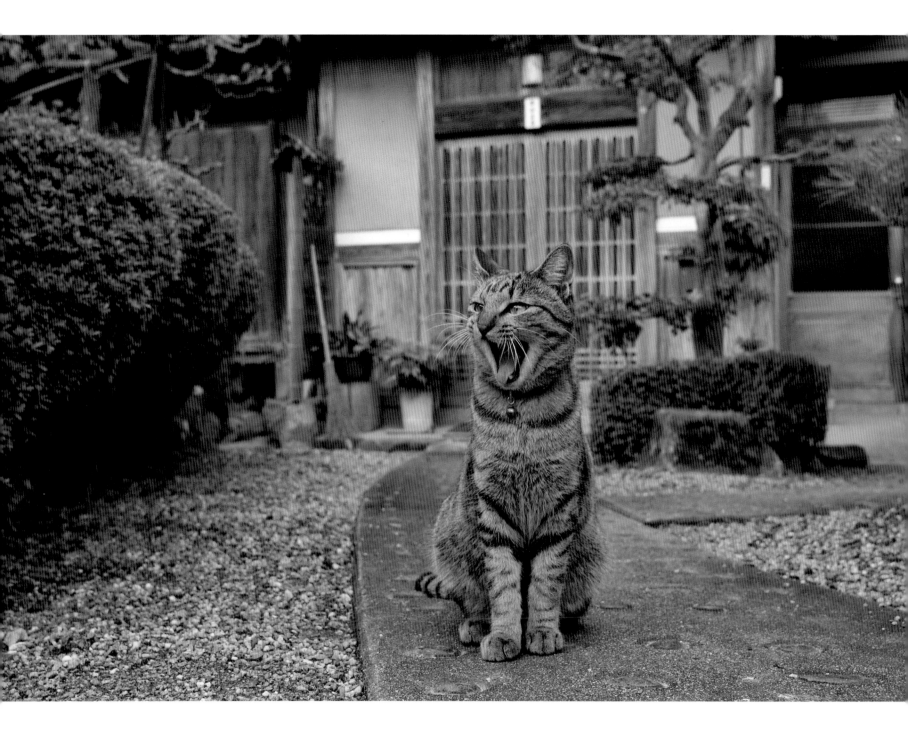

128      An early start.

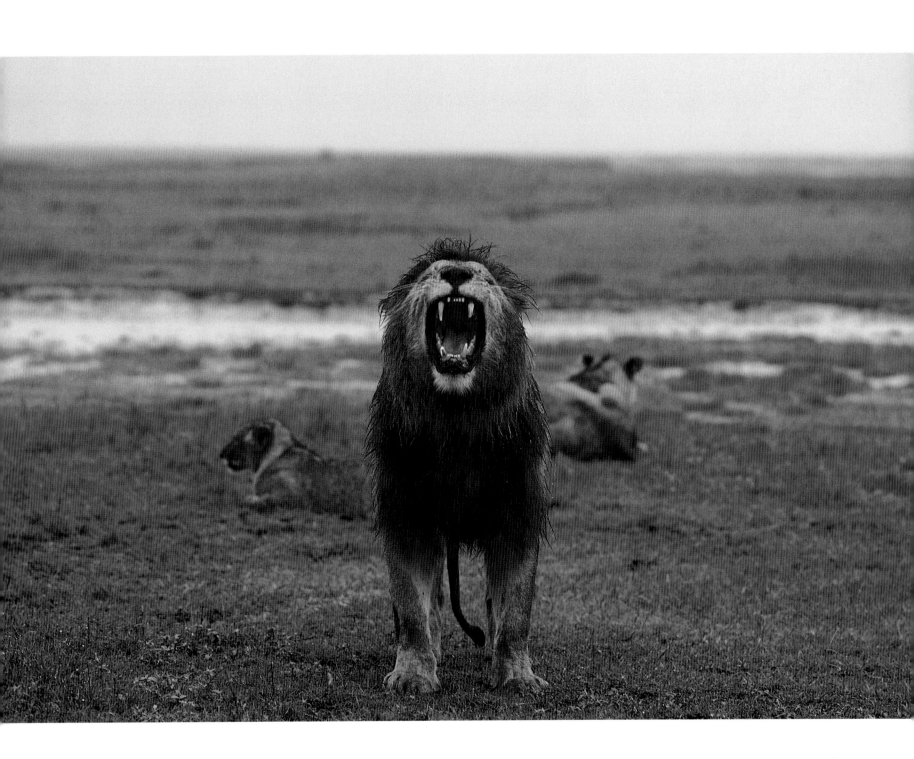

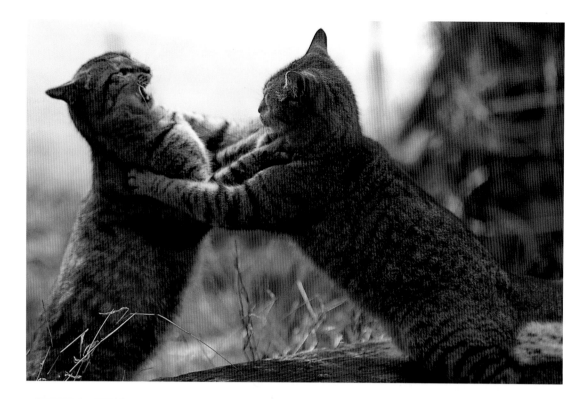

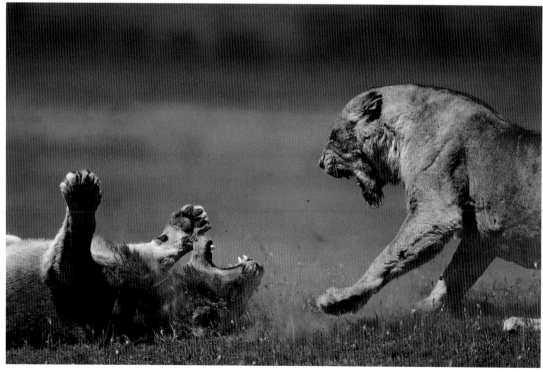

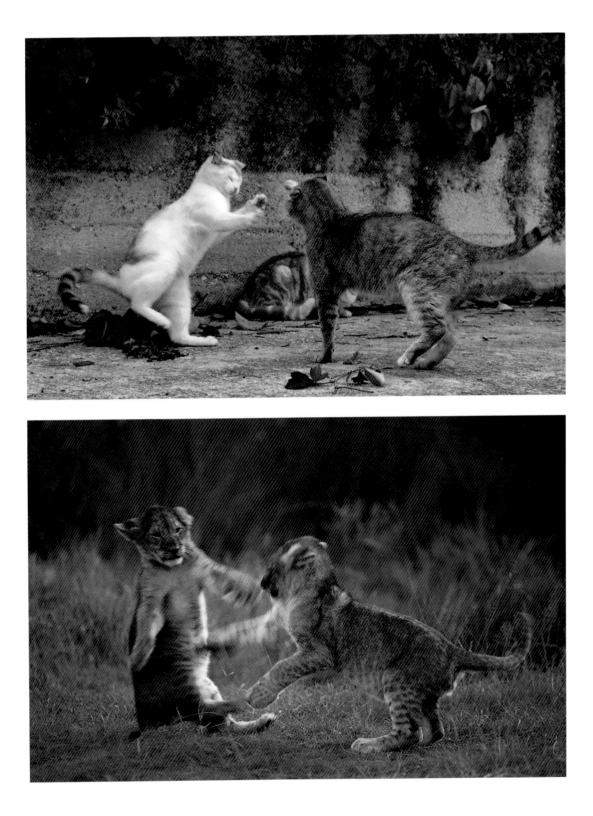

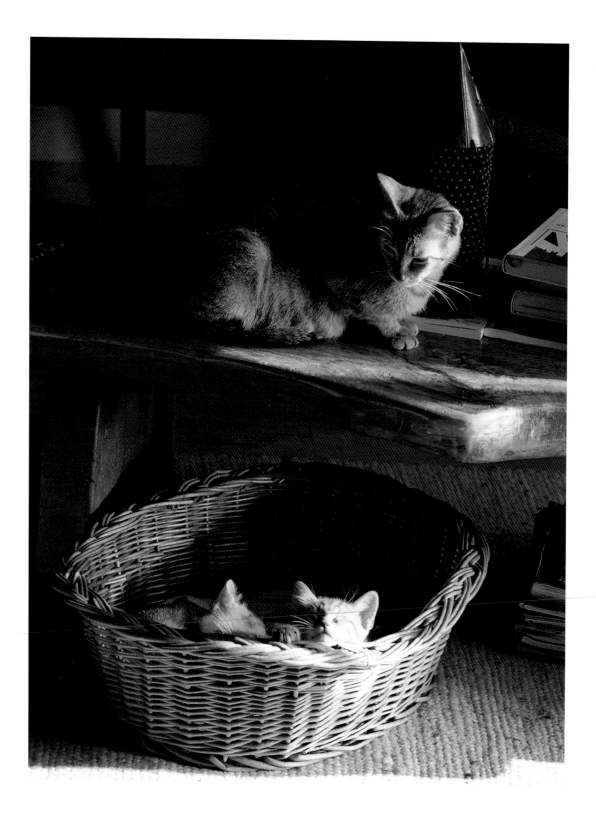

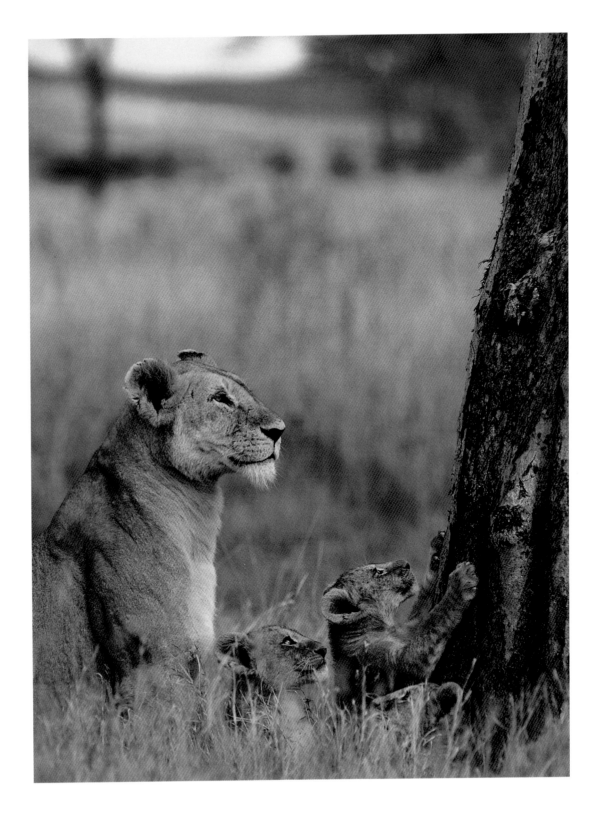

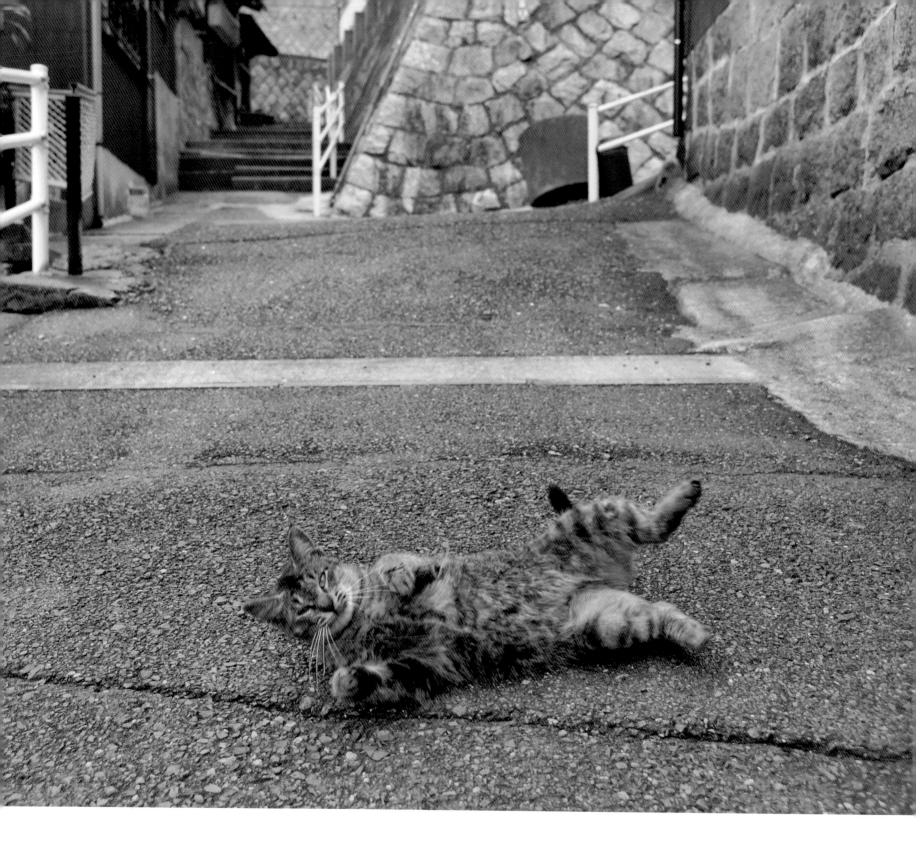

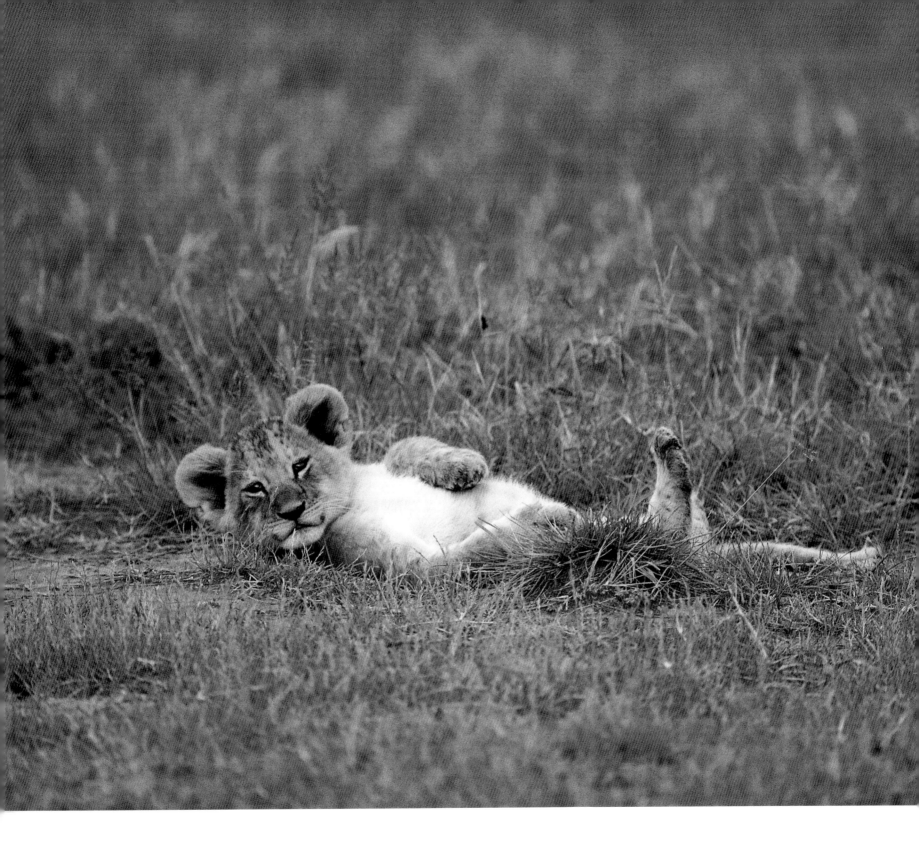

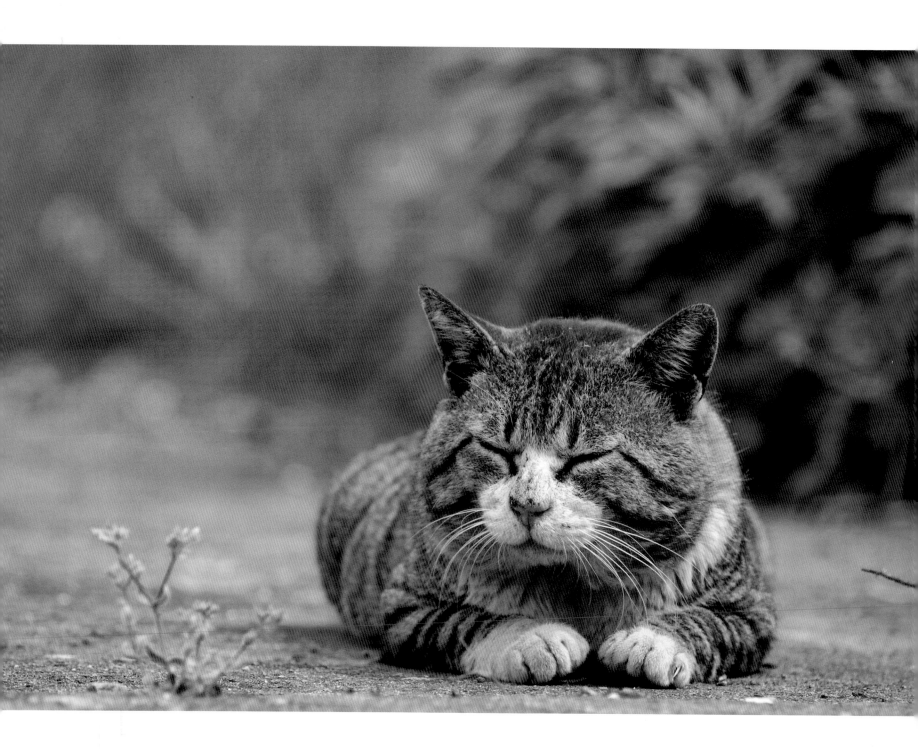

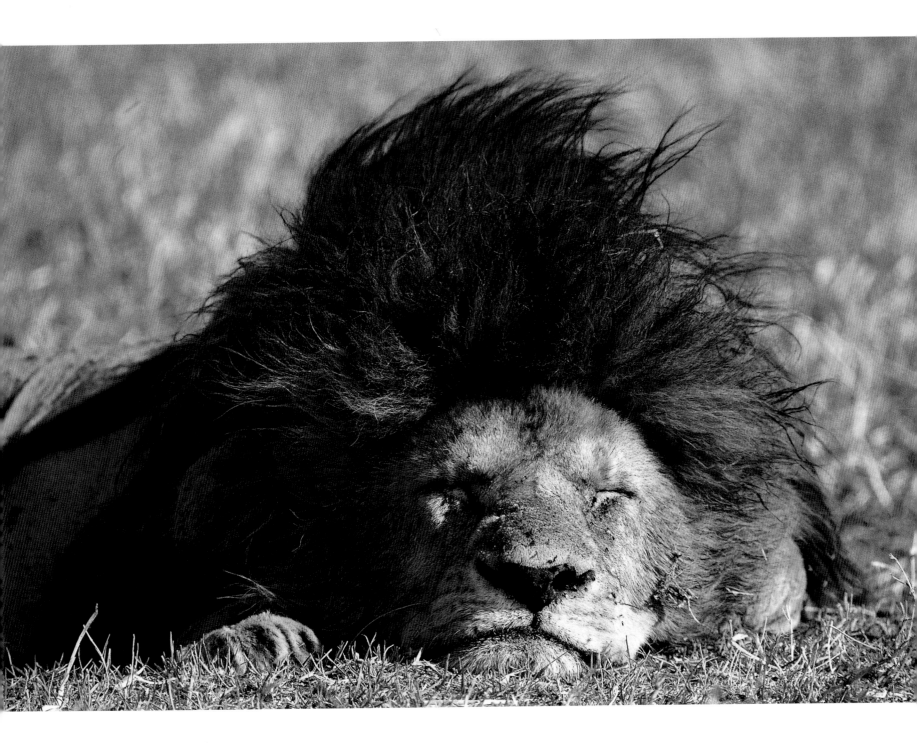

A quick rest in the sun.

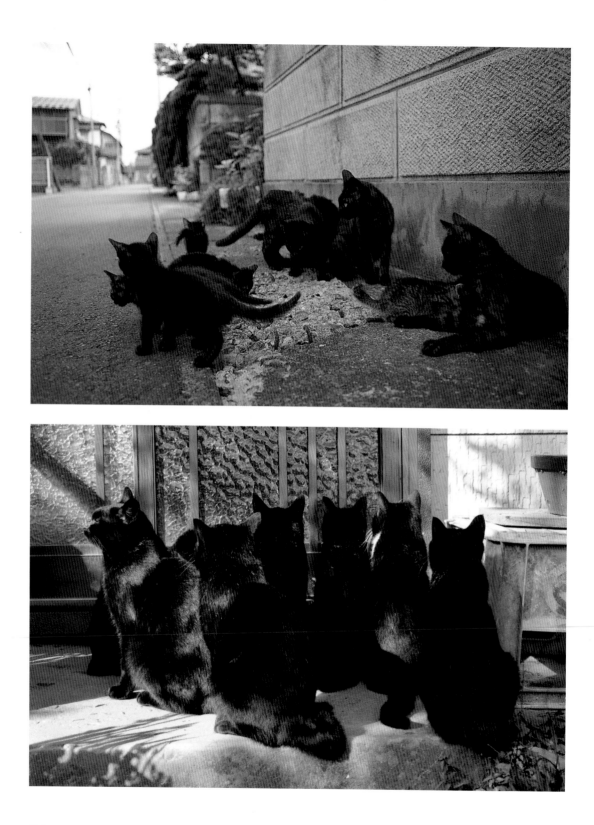

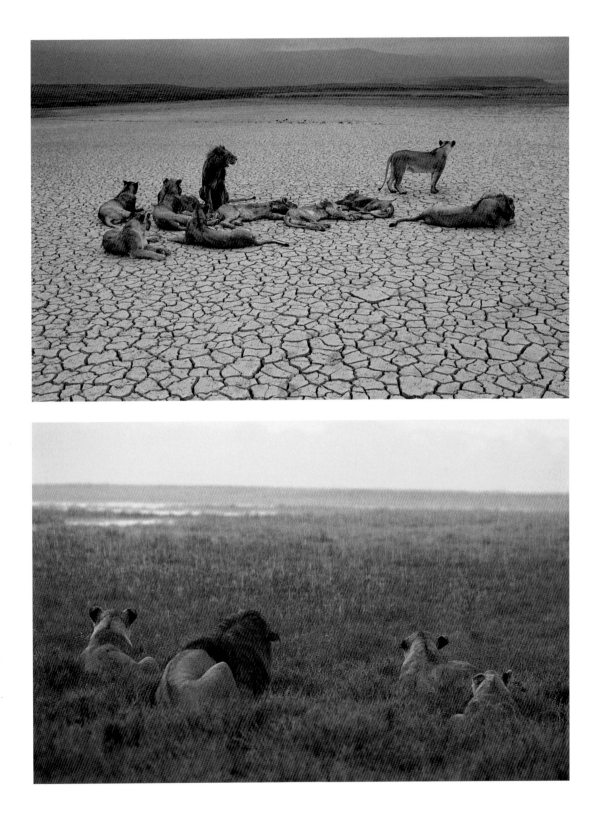

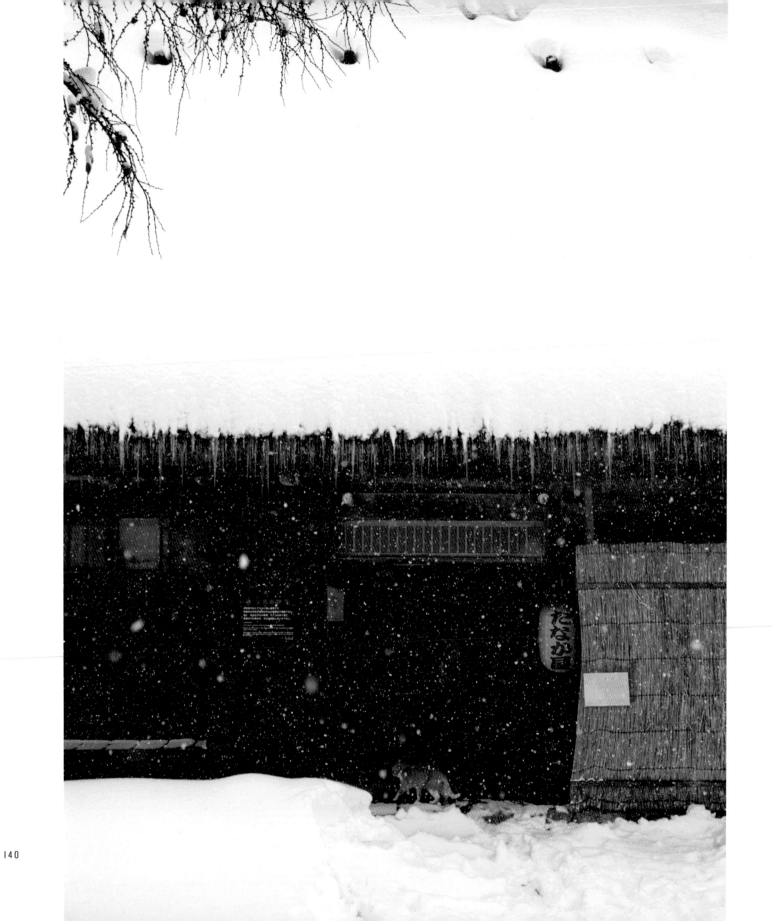

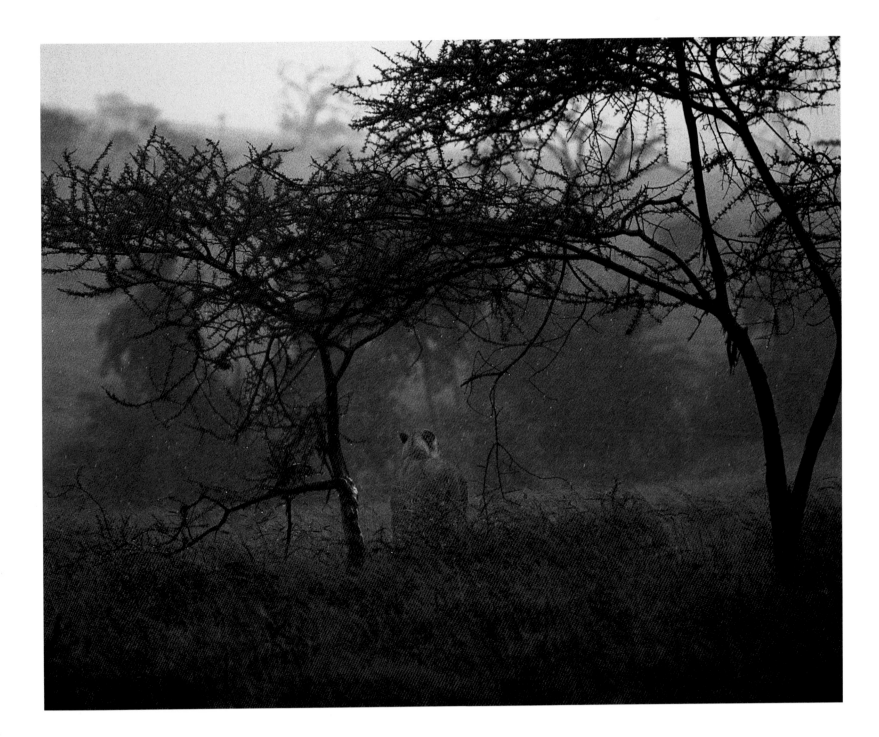

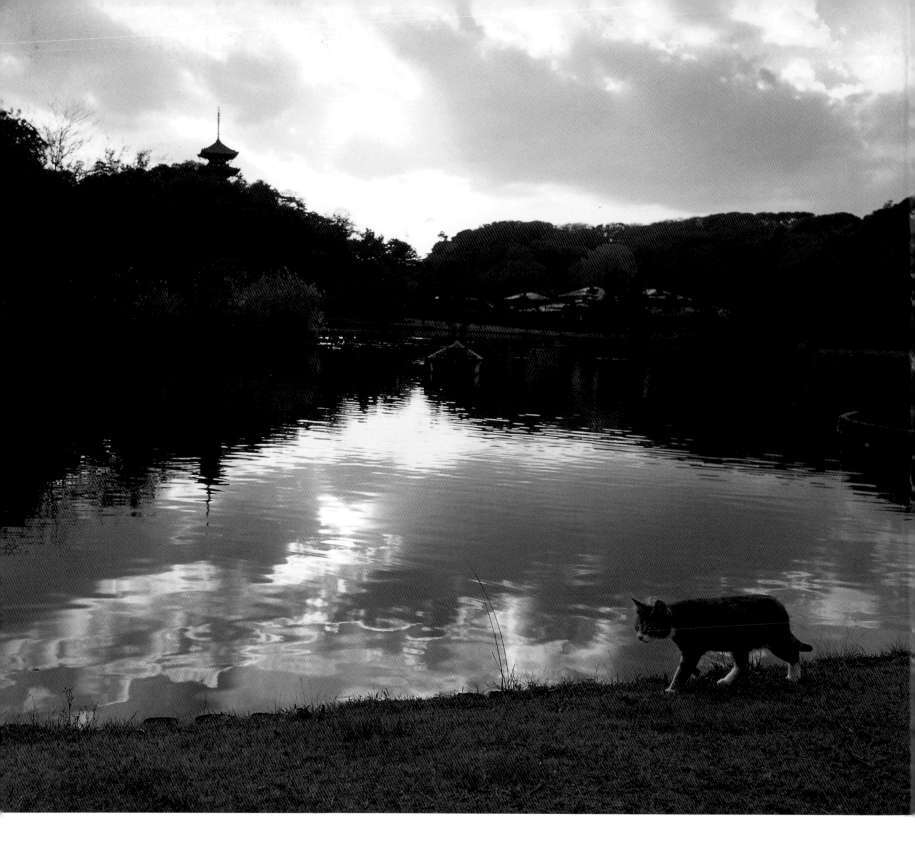

The day comes to an end.

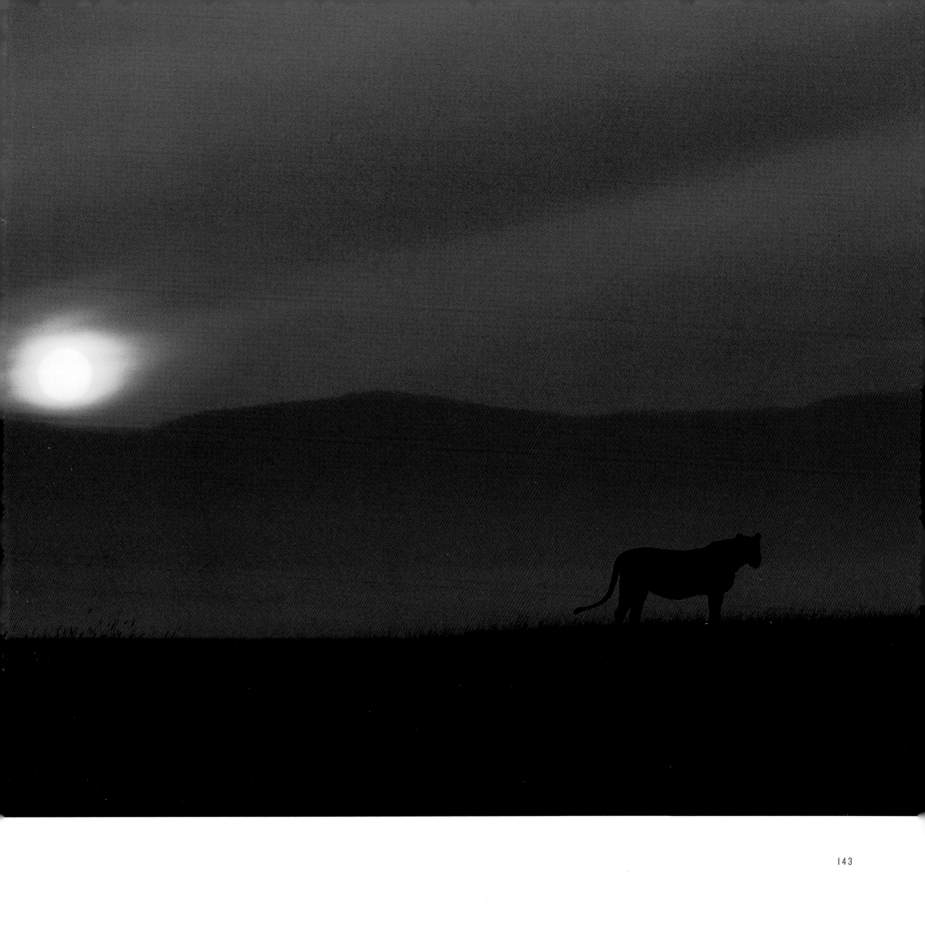

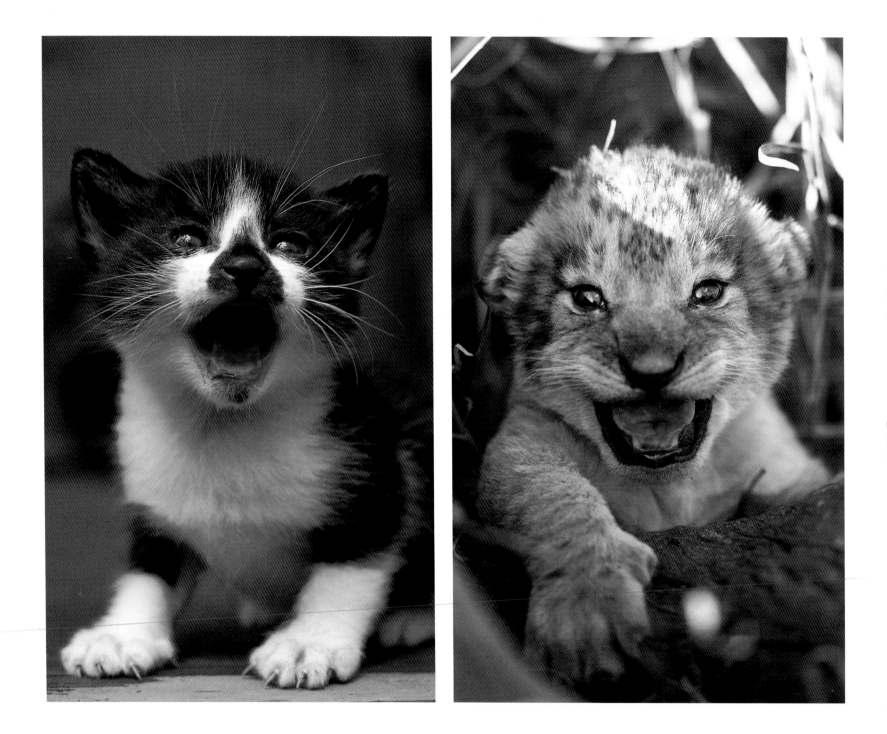